STOKE
THROUGH TIME
Mervyn Edwards

AMBERLEY PUBLISHING

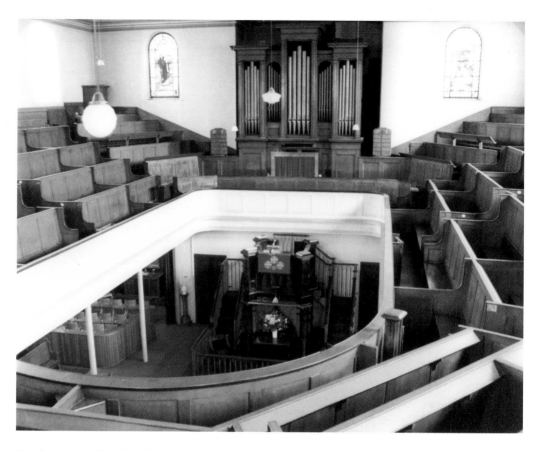

Wesley Methodist Church (Now Demolished) Interior, 1983
Here is a beautiful interior photograph of the Wesley Methodist church of 1816, which stood on the corner of Epworth Street and Hide Street. The church was to suffer from wet rot and woodworm in the gallery, prior to demolition in 1983. The weight of the huge organ in the gallery had created a potentially dangerous bulge in the walls. Photographs were taken of the interior and these are kept in the church's archives.

First published 2013

Amberley Publishing
The Hill, Stroud, Gloucestershire, GL5 4EP
www.amberley-books.com

Copyright © Mervyn Edwards, 2013

The right of Mervyn Edwards to be identified as the
Author of this work has been asserted in accordance with
the Copyrights, Designs and Patents Act 1988.

ISBN 978 1 4456 1727 5 (print)
ISBN 978 1 4456 1739 8 (ebook)

British Library Cataloguing in Publication Data.
A catalogue record for this book is available from the
British Library.

Typesetting by Amberley Publishing.
Printed in Great Britain.

Introduction

Where is the real Stoke-upon-Trent? It depends on what you consider gives it its true identity, and even then, the answers that offer themselves up to us evince a will-o'-the-wisp slipperiness.

Perhaps we should look no further than the church of St Peter ad Vincula, whose own importance as the ecclesiastical fulcrum of the Potteries has in recent years been underlined by its having been awarded Minster status. Stoke, after all, means 'place' or 'holy place' – surely an indication that the various incarnations of St Peter's, dating back to Saxon times, have constituted the heart and soul of the town.

It's an argument that we can warm to, though we should not run away with the idea that Stoke could boast many inhabitants. In the Middle Ages, the main centre of population was around Penkhull village.

Stoke itself is only mentioned in connection with its church in the Domesday Survey of 1086. There was precious little else there. That St Peter's, through successive reconstructions, remained a focal point in the town buttresses arguments about its geographical, as well as spiritual, significance. Nevertheless, the marshy character of the land around the church deterred the proto-planners of the town from building much around it until a relatively late date.

Improved communications helped to put Stoke on the map. The road from Newcastle to Uttoxeter, which passed through Stoke, was turnpiked in 1759, and the Trent & Mersey Canal was completed in 1777. These developments prompted Stoke's growth from village to town.

However, the nucleus of the town in the 1790s was not to be found around St Peter's, but around the Town Hall of 1794, built in Market Street, later Hill Street.

A building that came to be known as the hide and skin market was erected above it in 1835, at a time when other plans were being made to develop the area around Stoke's rebuilt church. A civic tug-o'-war ensued.

Mr William Williams, a market trustee, inserted a notice in the local press stating that the old market 'has been established upwards of forty years, and it is in the midst of the population; but that the New Market attempted to be established by Mr Tomlinson, in a situation calculated to answer the interested purpose of promoting the sale of the Glebe Lands, is inconveniently situated, and remote from the town.'

However, Tomlinson and a company of shareholders succeeded in establishing a new Town Hall and market in Glebe Street, thus creating a new town hub.

That historian John Ward was able to describe Stoke, around 1840, as 'the most compact and regular Town in the Potteries' – and one 'almost wholly of modern erection' – speaks volumes about the influence of the political grandees of the time, its leading business figures, and manufacturers/ landowners like Spode and William Taylor Copeland, who created much of the town's infrastructure, including workers' houses, shops and pubs.

Thus, the seeds of a planned town were sewn.

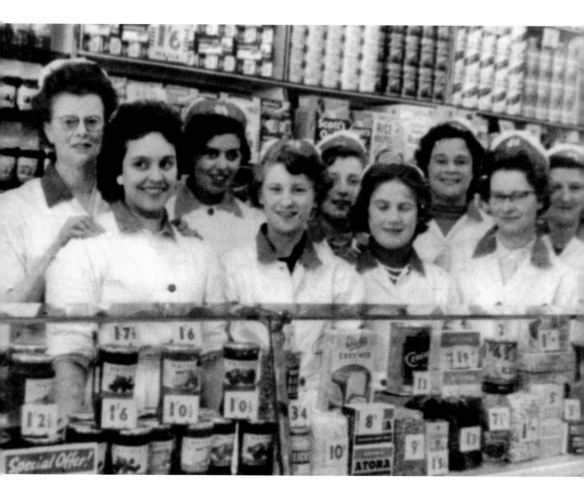

Maypole Shop, Probably Late 1950s
In 2007, *Sentinel* correspondent Sylvia Dodds (*née* Horrobin) described her experiences of the Maypole in the late 1950s. The shop sold bacon, butter, lard, sugar, dried peas and canned food. She added, 'Our shop was an all-female one, so we had to unload the delivery lorry, sliding the heavy boxes of canned food down a wooden ramp into the cellar.' She recalled the manageress, Joan Kelsall, and the assistants, including Irene Warrington, Joan Loach, Sheila Thomas, Pat Lomas, Doreen Hill and Maureen Bland.

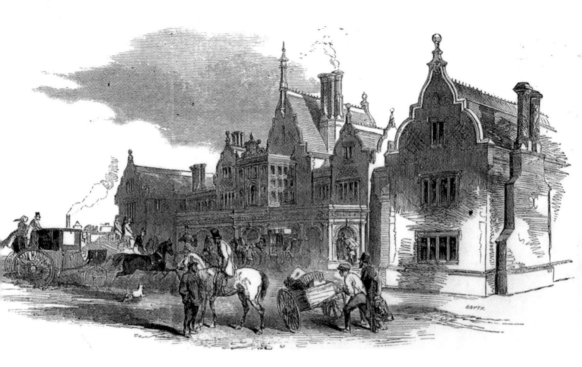

Stoke Railway Station, 1849 and 2013

A look at Stoke's streets can begin at no better place than Winton Square, whose railway station – opened in October 1848 – is depicted in the *Illustrated London News* edition of 16 June 1849. The station was designed with gabled parapets, mullioned windows and 'old-fashioned brick chimneys'. The architect of the station was H. A. Hunt of London. Alterations followed over the years, notably the glazing in of the seven-arch stone portico by 1870.

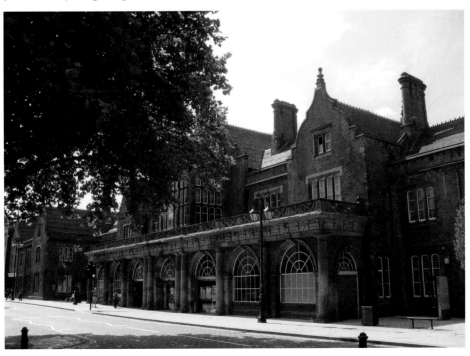

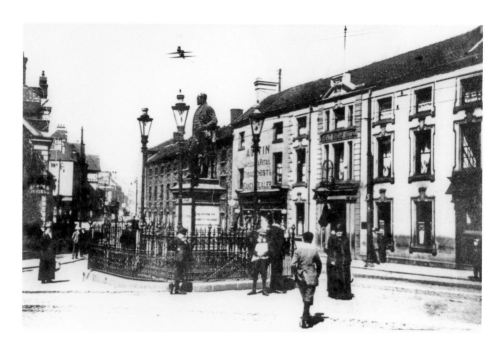

Campbell Place, Early Twentieth Century and 2013

Following the death of Colin Minton Campbell in 1885, the Mayor of Stoke initiated an appeal to raise money for a statue of the pottery manufacturer. The statue, by leading civic sculptor Thomas Brock, was unveiled by the Duchess of Sutherland in 1887. Around 1960, the Wheatsheaf was still recognisable as the coaching house of late Georgian times, notwithstanding alterations to the three-storey front in the later nineteenth century. However, in early 1963, it was demolished and rebuilt.

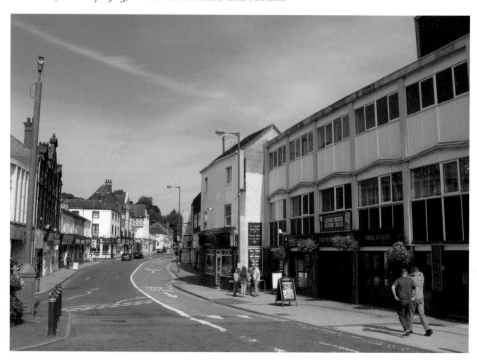

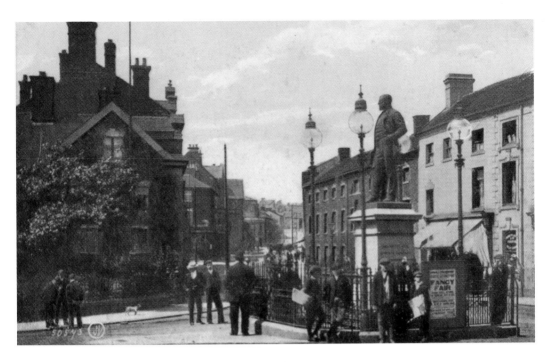

Campbell Place, Early Twentieth Century and 2013

Campbell Place appears as Eldon Place on Hargreaves' 1832 map. The Grapes pub is seen on the left of the photograph. This late eighteenth-century building was subsequently altered, perhaps at the time of its conversion to an inn around 1865. The pub stood on what was known locally as Jackson's Corner, because the Grapes was next door to Jackson's wines and spirits business. The Grapes and its garden were demolished in 1960, and replaced by a modern store.

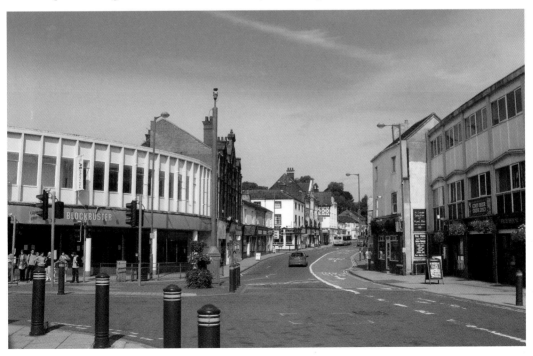

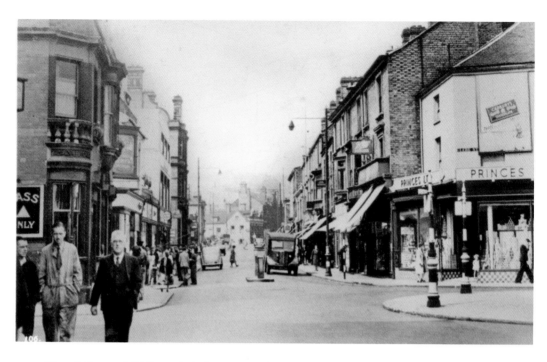

Church Street, Mid-Twentieth Century and 2013
The pub with the 'Bass Only' sign on the extreme left is the Ring o' Bells. Princes, on the corner of Glebe Street, was formerly C. Risely & Sons. Other well-remembered shops that traded in Stoke were A. L. Jones (tailoring and clothing), George Hollins & Sons (ironmongers), which had a hanging sign resembling an outsize padlock, Dale's chemist, Home and Colonial, Woolworths, and Fleet's furniture store, which had been founded in 1863.

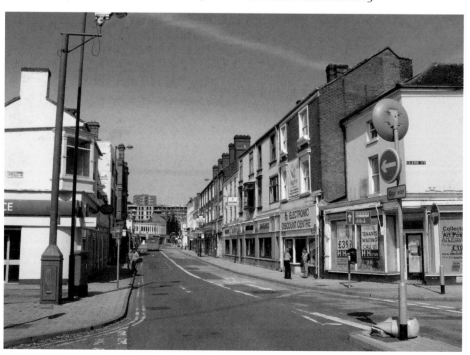

Glebe Street, 1970s and 2013

The tall building at the end of Brook Street was once the National Provincial Bank of England. The Glebe Hotel, on the right, incorporated a billiard room and a vaults when up for let in 1881. A surviving early twentieth-century photograph of the Glebe shows the balcony windows and wrought-iron railings above the ground floor. It was taken over by the Market Drayton-based Joule's Brewery in 2009, reopening after a splendid refurbishment in October 2010.

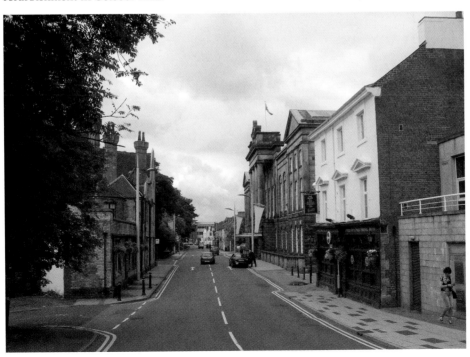

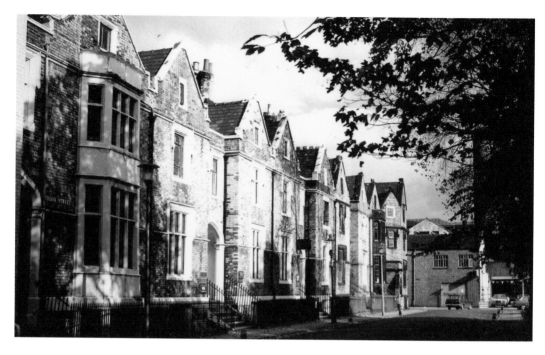

Brook Street, 1970s and 2013
A plan of the area around Stoke churchyard, dated 1830, shows the new streets laid out by John Tomlinson, the patron of Stoke rectory. The houses were completed in 1838 and were advertised to let in the local newspapers. They possessed 'every convenience for the residence of the most respectable families and invite the attention of members of the Medical and Legal professions, who may be desirous of settling in that part of the Potteries.'

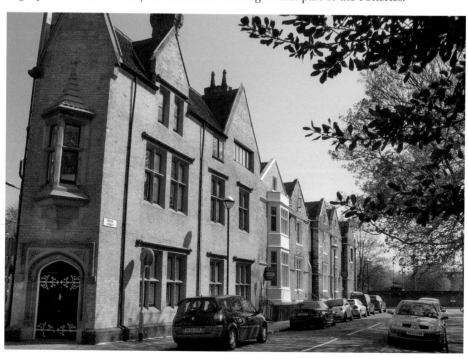

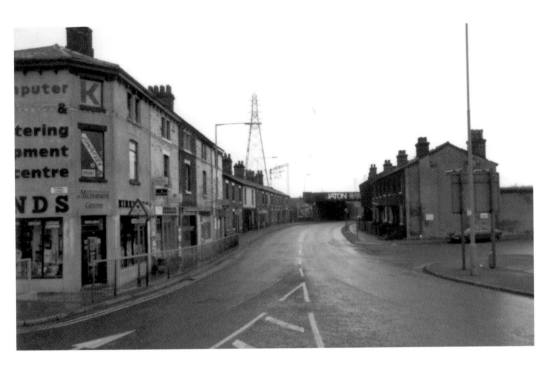

City Road, *c.* 1980 and 2013

City Road connects Stoke and Fenton. The traveller passed Fenton Vivian (or Little Fenton) on his left and continued along the road, which became King Street. From here, it was a relatively short distance to Longton. This thoroughfare is on a main bus route and can often be clogged with traffic.

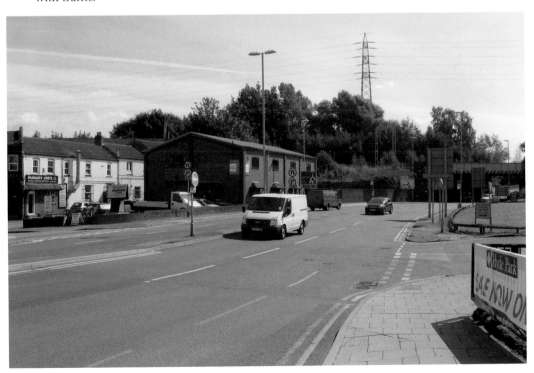

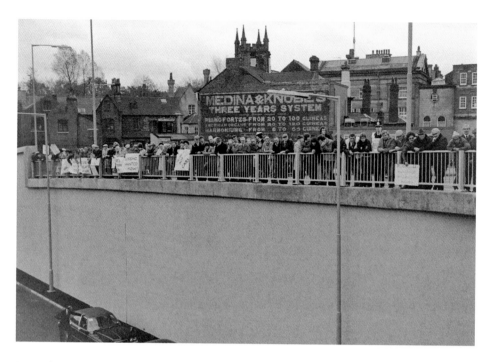

D Road, 1977 and 2013

Queensway was opened in 1977, its name a tribute to the Queen's Silver Jubilee of that year. However, with typical local iconoclasm, it became rather better known as the Potteries D Road, a reference to its configuration. Much of Stoke was demolished to make way for the new road, including thirteen pubs: the Copeland Arms, Red Lion, Saracen's Head, Denbigh Castle, Bridge Inn, Crown Inn, Cooper's Arms, Wharf Tavern, Trent Tavern, Locomotive, Duke of York, and Pike and the Winger.

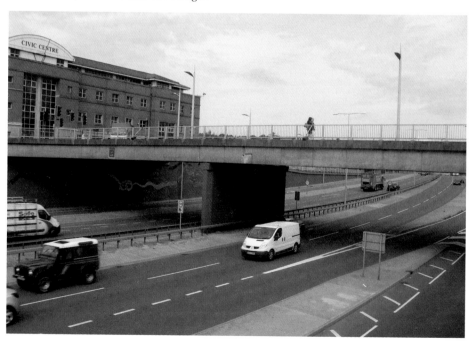

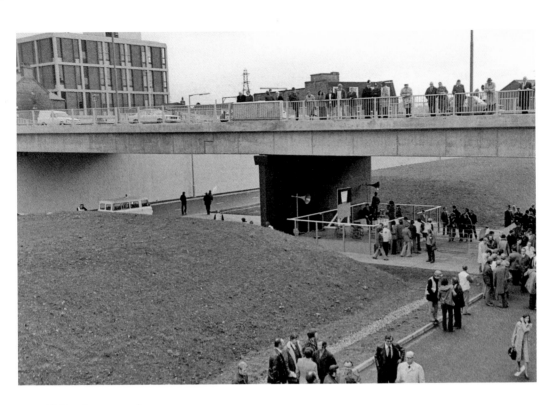

D Road, 1977 and 2013

Many of the buildings were photographed by local photographer Jim Morgan prior to their demolition, and several of the pictures later appeared in the *Sentinel* newspaper. The new urban expressway significantly improved road communications in the city, but ultimately accelerated Stoke-upon-Trent's decline as a shopping centre.

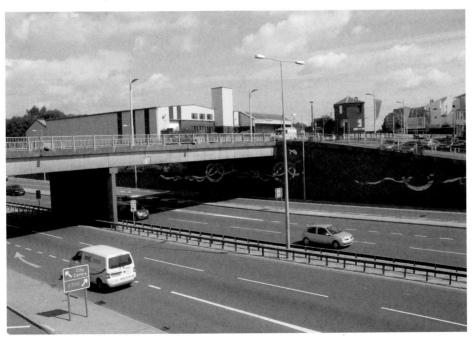

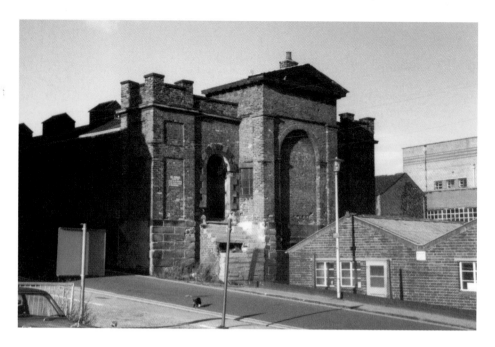

Former Hide Market, *c.* 1980 and 2013

The traditional market place in Stoke was held around the Town Hall of 1794, built below what is now Epworth Street. However, when several affluent inhabitants launched a scheme to remove the market to newly built Glebe Street, a large number of local traders responded by establishing a new covered market in 1835, which opened above the 1794 Town Hall. The 1835 building was used as a shambles by 1859, and by at least 1872 a hide and skin market was held there.

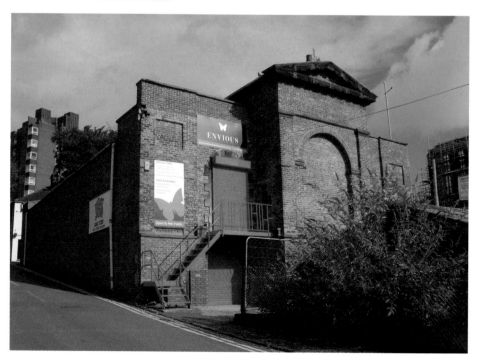

Former Tourist Information Centre, Glebe Street, 1992 and 2013
Here is a reminder that information on where to visit in the city was formerly available a short distance away from the railway station. An association of visitor guides for the city regularly met in the North Stafford Hotel in the 1980s and early 1990s. Among them were Peter Green, Syd Bailey, Dave Scrivens, Pam Rawlins, Phil Stockton, Jackie Thompson, Bryn Shaw, Rob Burton, Fabienne Dixon and Claire Fitton.

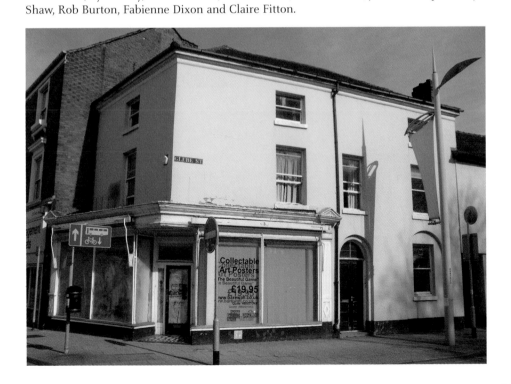

Former Rialto, 1993 and 2013

The Rialto ballroom and café is now operating as the K.Dee.K. Danceworks, a dance school. However, this Church Street venue was once a magnet for ballroom dancers. One long-serving waitress in the café was Betty Ottley, better remembered by her married name of Betty Buckley. She was the landlady of the Golden Cup pub in Hanley from 1952 to 1991.

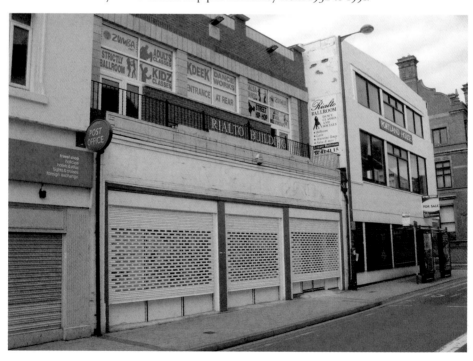

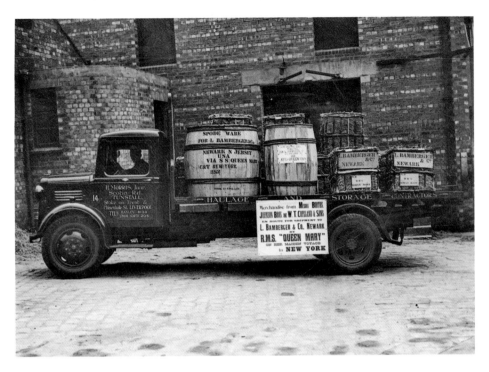

Spode Lorry, 1936, and Memorial to Spode, Stoke Minster, 2013

Our section on local industry starts with an illustrious name. Josiah Spode I was, in 1762, recruited as the factory manager at Banks' and Turner's factory in Stoke. They manufactured white stoneware. Spode bought the factory on mortgage from Banks in 1770, becoming the sole owner in 1776. Here, we see wares leaving Spode's Church Street entrance in a lorry. Spode products were exported worldwide, and this shipment was destined for the United States, via the RMS *Queen Mary* on her maiden voyage.

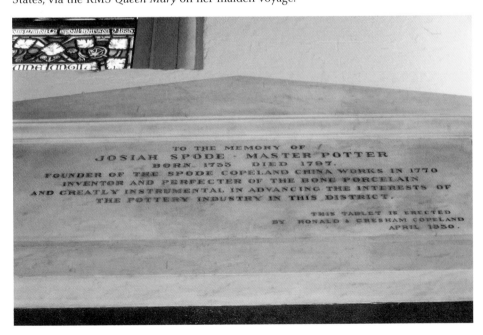

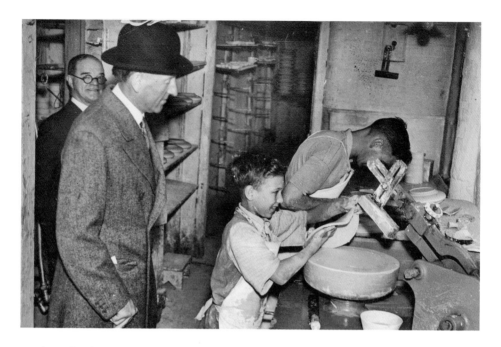

Lord Londonderry's Visit, 1938, and Memorial to Spode, Stoke Minster, 2013

The 7th Marquess of Londonderry visits the platemaking workshops at Spode in June 1938, just a year before the outbreak of the First World War. The marquess, whose attempts at pre-war Anglo-German diplomacy led to him being accused of being a Nazi sympathiser, died not long after the war. The memorial in Stoke Minster reminds us that Spode I was succeeded by his son (1755–1827). He was already working for the factory and forged a reputation as an innovator in technology.

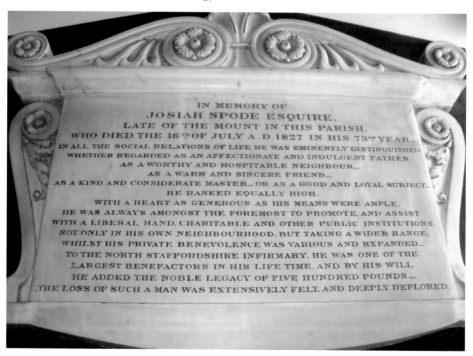

IN MEMORY OF
JOSIAH SPODE ESQUIRE,
LATE OF THE MOUNT IN THIS PARISH.
WHO DIED THE 16 TH OF JULY A.D. 1827 IN HIS 73 RD YEAR.
IN ALL THE SOCIAL RELATIONS OF LIFE HE WAS EMINENTLY DISTINGUISHED
WHETHER REGARDED AS AN AFFECTIONATE AND INDULGENT FATHER
AS A WORTHY AND HOSPITABLE NEIGHBOUR—
AS A WARM AND SINCERE FRIEND—
AS A KIND AND CONSIDERATE MASTER—OR AS A GOOD AND LOYAL SUBJECT—
HE RANKED EQUALLY HIGH.
WITH A HEART AS GENEROUS AS HIS MEANS WERE AMPLE.
HE WAS ALWAYS AMONGST THE FOREMOST TO PROMOTE, AND ASSIST
WITH A LIBERAL HAND, CHARITABLE AND OTHER PUBLIC INSTITUTIONS.
NOT ONLY IN HIS OWN NEIGHBOURHOOD, BUT TAKING A WIDER RANGE,
WHILST HIS PRIVATE BENEVOLENCE WAS VARIOUS AND EXPANDED—
TO THE NORTH STAFFORDSHIRE INFIRMARY, HE WAS ONE OF THE
LARGEST BENEFACTORS IN HIS LIFE TIME, AND BY HIS WILL
HE ADDED THE NOBLE LEGACY OF FIVE HUNDRED POUNDS—
THE LOSS OF SUCH A MAN WAS EXTENSIVELY FELT, AND DEEPLY DEPLORED.

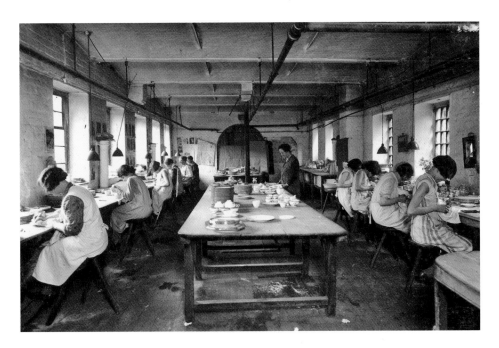

Burnishers at Work, Date Unknown, and Spode Graves, Stoke Churchyard, 2013
This photograph of burnishers at work shows a typical Spode workshop. The rooms were wide enough to have workbenches on both sides, with windows to admit natural light. There were stillages (shelves) in the middle where new ware was brought in, or where the work was stacked to be taken away. The ladies are sitting on three-legged stools. Note the barrel-vaulted ceiling with steel girders, a design commonly used in the factory. The graves of Spodes II and III are also shown.

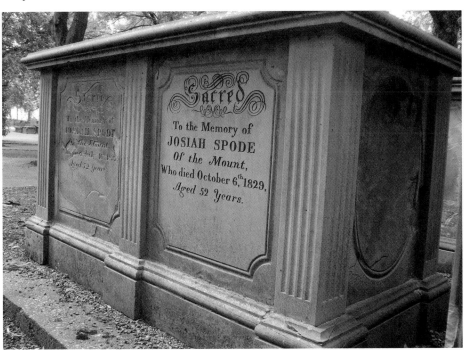

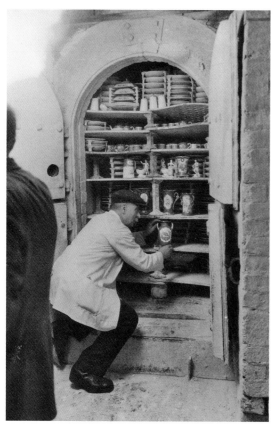

Mr Simpson Loading China, Date Unknown, and Spode Works Sign, 2004
Spode had a London warehouse and showroom. Affluent customers could order conveniently from samples without needing to visit the factory itself. Spode made a lot of ware for the *Titanic*. Here is Mr Simpson loading the china decorating kiln at Spode, with hand-painted vases, figurines and teacups. The role of the kiln placer was extremely skilled, highly regarded and well-paid. High-end, hand-painted items could take months to produce. The deteriorating process alone would include multiple firings of a week, or more in a coal-fired bottle oven. Historically, workers were paid for 'good from kiln' pieces and the potential loss of income would be catastrophic if a major kiln failure occurred. Eventually, 'good from hand' became the accepted practice.

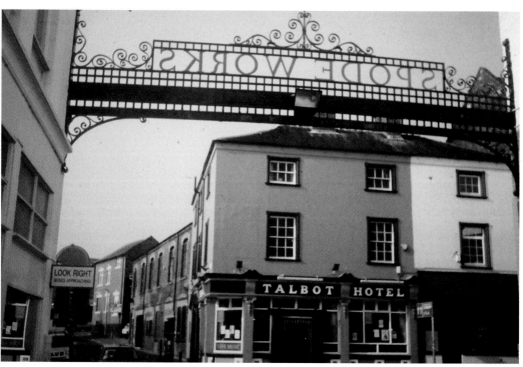

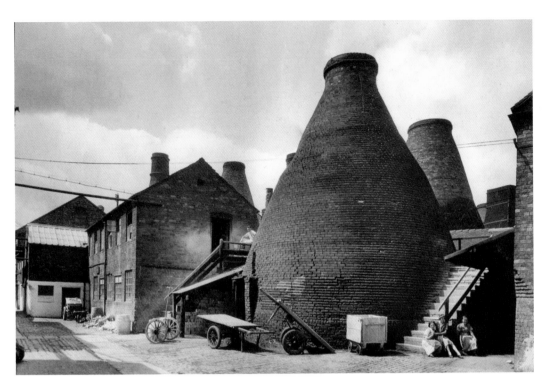

View of Factory, Date Unknown, and Factory from Kingsway, 2013

Here are workshops and bottle ovens at Spode. Around 1836, Wedgwood operated fifteen coal-fired bottle ovens and Minton had twenty. The Spode factory outweighed them all with twenty-five. The last bottle oven collapsed in the 1970s, narrowly missing passers-by. It had been built in 1797. At the height of production, Spode used around 200 tons of coal every week for the firing process. The carts were used for moving the blocks or cylinders of damp clay around the factory.

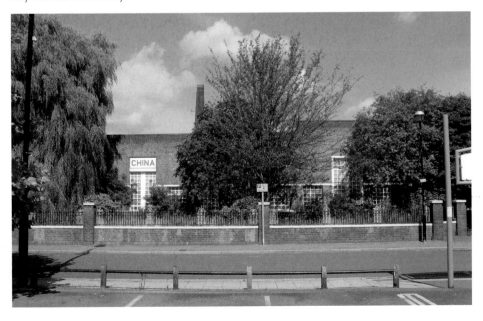

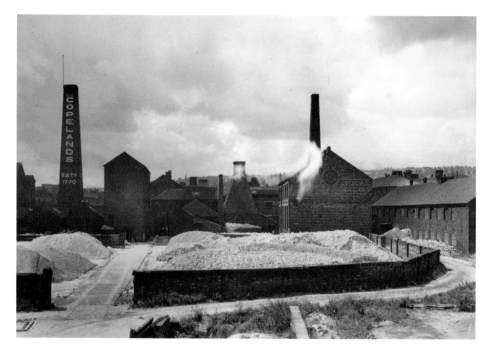

The Clay Bank, Date Unknown, and Plaster Moulds, 2013

Here is the clay bank to the rear of the factory, where the clay was piled to allow it to weather. This emulates the Chinese practice, where stores of clay are laid down for future generations, as weathered clay, broken down over time, produces a much more malleable clay body. The clay banks, however, became dirty, and weathered clay had to be filtered to clean it before use to remove coal and iron debris.

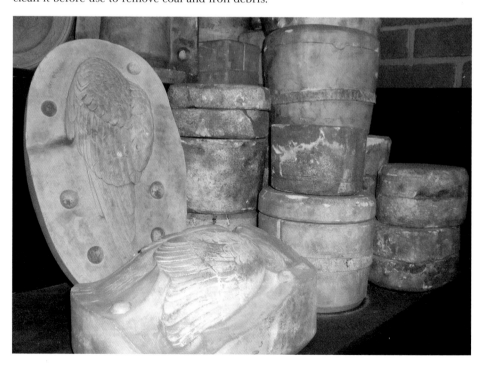

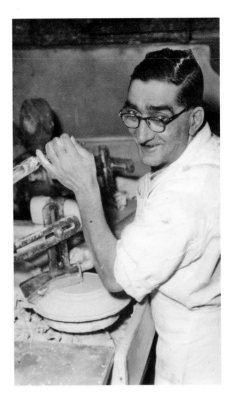

Ernest Bates, Date Unknown, and Bev Booth, 2013
In 1829, the historian Simeon Shaw described the third Josiah Spode's works as 'in extent not surpassed in Europe … the manufacture includes every variety of the finest kinds of Porcelain and Pottery, with all the ornaments and embellishments calculated to gratify the desires of the luxurious, and the taste of the connoisseur.' Ernest Bates' family recollect that he was the last hand thrower of plates at Spode, and he then worked as a jollier. He had great skill as a platemaker and was apparently so successful at making plates without getting air under the clay that he was once filmed working so that his technique could be analysed. Bev Booth is a friendly face at the Spode Works Visitor Centre.

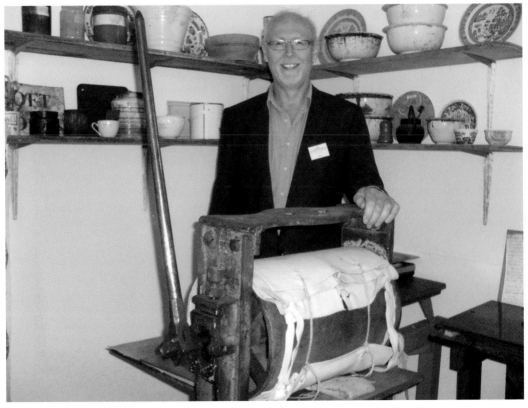

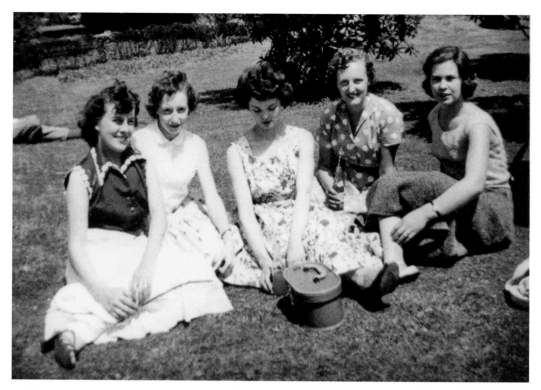

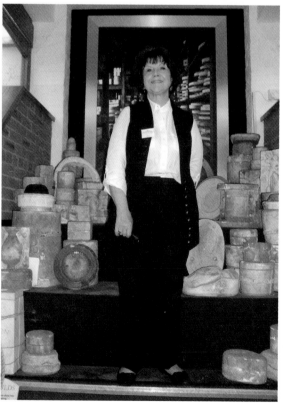

Pauline Dawson and Friends, Early 1950s, and Betty Lewis, 2013

Pauline Dawson (*née* White) was a paintress at Spode. She is shown, second from the right, having lunch in St Peter's churchyard, in the company of her friends and co-workers. Betty Lewis is a volunteer at the present Spode Works Visitor Centre. She explains: 'The factory continued to manufacture until 2008, but even now, there are many people who worked here who come back time and time again to the Spode Visitor Centre because they feel an affinity with the place.' Betty refers to the family atmosphere on the old factory. This is underlined by the recollections of Mavis Potts, interviewed by the author in 2009: 'At Christmas and Easter in the 1950s, concert parties were formed by various departments. Workers might perform a song from the shows or a satirical sketch, or there might be a choir concert in the large canteen.'

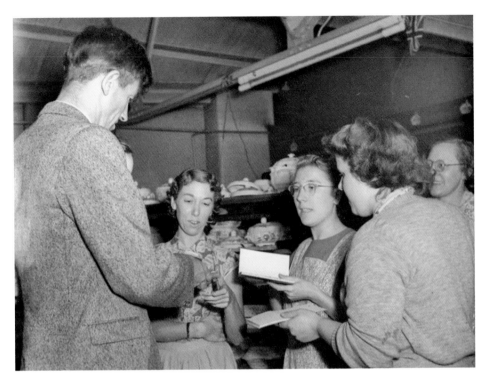

Sir Edmund Hillary's Visit, 1953, and Prince Charles' Visit, 1998

Sir Edmund Hillary signs autographs at the factory. The New Zealand-born explorer and mountaineer visited Spode on 16 October 1953, by which time he was a huge, international celebrity following his successful ascent of Mount Everest, with Tenzing Norgay, on 29 May. HRH Prince Charles visited in 1998. Here he shakes hands with a selector, who chose the finished selection of ware before an order was despatched. Spode's MD, Paul Wood, is third from the left with a beard.

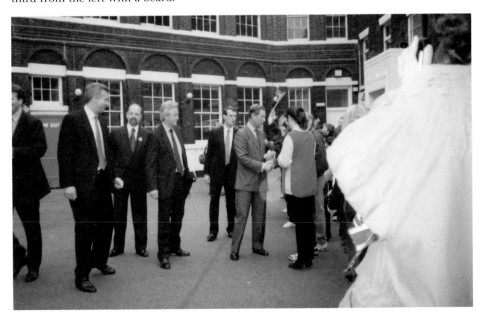

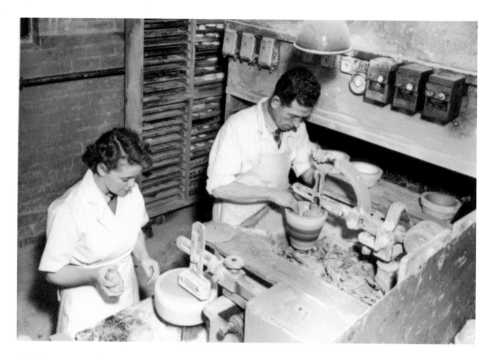

Jollying at Spode, 1957, and Spode Site, 2013

A series of official photographs showing the stages of production were taken at Spode in 1957. Here earthenware cups and bowls are being made. The lady is flattening the clay into a batt, or sheet, of set thickness. The man then presses the batt into the bowl mould, where it is shaped and trimmed before being placed in a dryer. The dryer is seen on the man's right. The cups and bowls are placed on the shelves and handles are subsequently added.

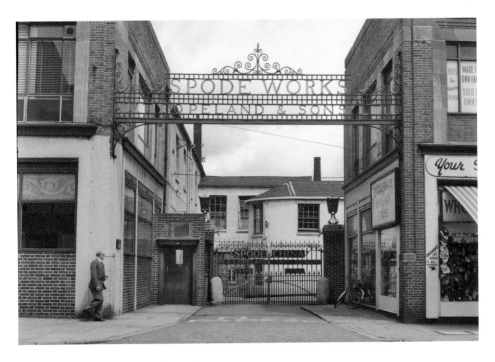

Church Street Entrance, 1960 and 1994

The Church Street entrance to the Spode factory was once a coaching arch, but the Church Street frontage has since been changed. The iconic Spode Works sign is bowed – and has been since it was installed. The span between the buildings was measured at ground level, and proved to be narrower than expected at the height where the sign was to be fitted. Additional brickwork had to be chipped out of the buildings to accommodate it.

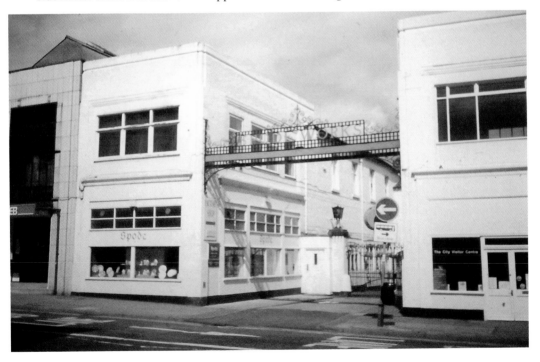

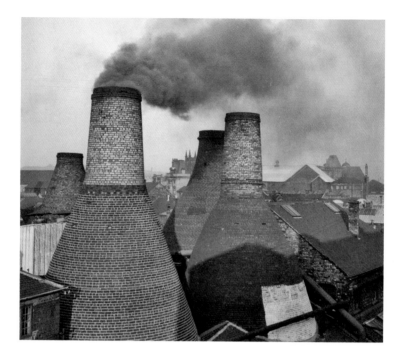

Kiln Firing at Spode, 1960, and Spode Site, 2013
One of the last china biscuit oven firings was seen at Spode in 1960. Art Director Harold Holdway's photograph later appeared in *The Times* on 2 June 1960. The Spode Works Visitor Centre opened in February 2013, financed by a Heritage Lottery grant. It displays ceramic wares, antique factory tools and furniture, highlighting the contribution of Spode during the Industrial Revolution and beyond.

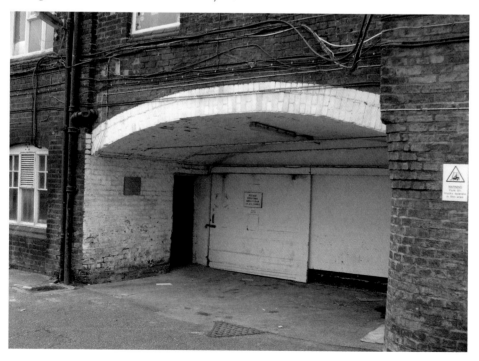

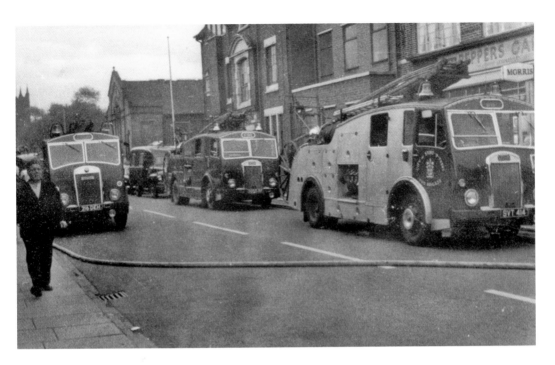

Coronation Pottery Fire, 1960s, and Lonsdale Street, 2013
The Coronation Pottery operated from around 1903 to the 1960s and stood on the corner of Lonsdale Street and Cornwallis Street. The chapel in the photograph also overlooked Lonsdale Street and belonged to the Primitive Methodists. This stood on the right of Stoke's graveyard extension of 1868. St Peter's church tower can be seen in the distance. The Coronation Pottery faced numerous terraced properties on the other side of Lonsdale Street.

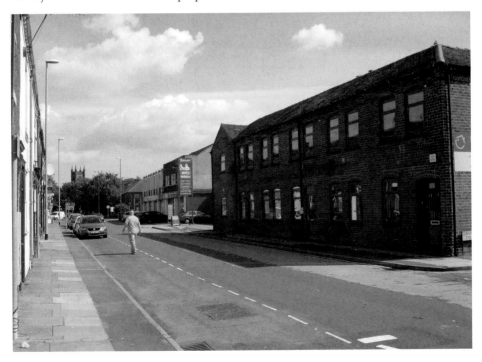

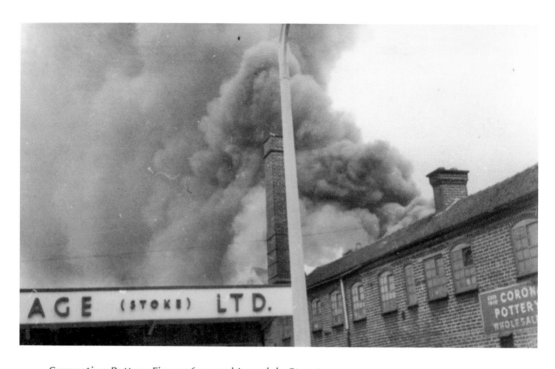

Coronation Pottery Fire, 1960s, and Lonsdale Street, 2013

Firefighting at Stoke is a fascinating story. By 1829, a fire engine was kept in the old Town Hall in Hill Street. However, the lack of a reliable water supply from the mains in the Stoke area sometimes undermined firefighting operations. Fires at the Noah's Ark pub in Hartshill in 1856, and Hartshill church in 1872 might well have been far more destructive but for the resourcefulness of firefighters and local people.

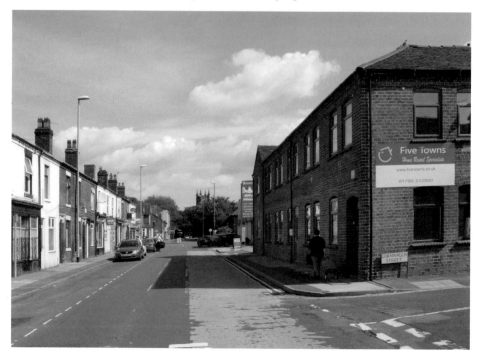

Planting a Tree at Michelin, *c.* 1997, and Michelin Roundabout, 2013

The next series of photographs features one of the city's greatest employers. The French tyre manufacturing company Michelin (founded in 1888) moved its UK headquarters from London to Stoke in 1927. The new factory was built at Trent Vale. The Michelin Man – properly named Bibendum – was a pile of rubber tyres in human form and became an advertising symbol for the company. Three Michelin Men are seen on this roundabout on Campbell Road.

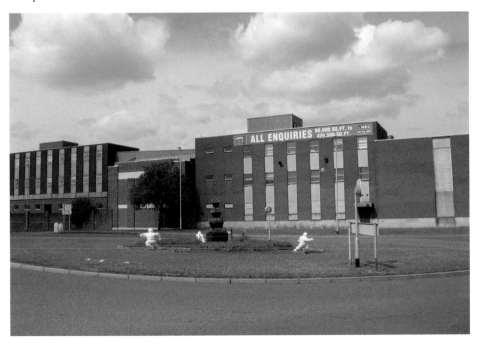

Michelin, 1999, and Sign for Michelin, 2013

Stoke-on-Trent's official handbook for 1939 was able to record that the Michelin Tyre Company Limited's factory, which occupied an area of 205 acres, embraced mills for rolling the raw rubber, machinery for weaving the fabric on which the tyres were built, and machines for wrapping the finished tyres. The guidebook also referred to the factory's sports grounds, comprising a cricket field, hockey field, football pitches and tennis courts.

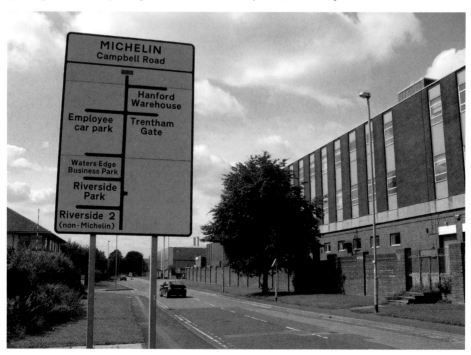

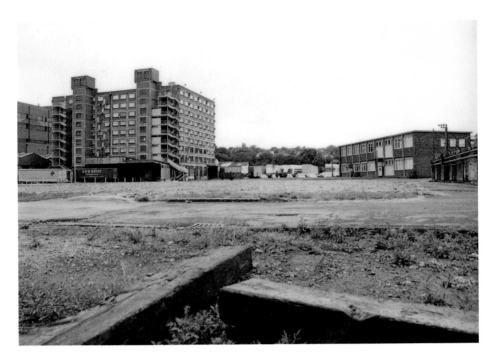

Michelin, 1991 and 2013

Entertainment was sometimes provided for employees off-site. For example, in 1928, the local press was happy to announce: 'The Canteen Club in connection with the Michelin Tyre Works at Stoke held a dance at the King's Hall on Saturday. Among the 800 persons present were a number of the firm's French employees and the function proved a miniature *entente cordiale.*'

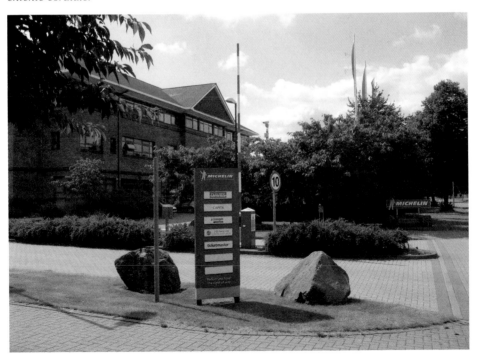

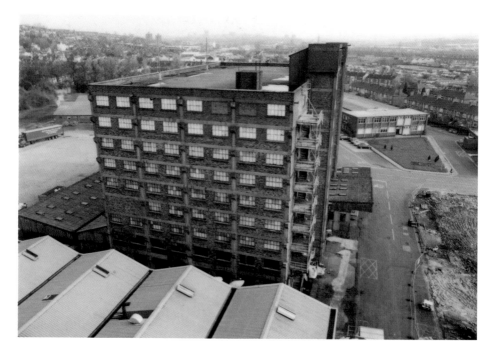

Michelin, 1999 and 2013

One long-serving employee was Dennis Pickford, who worked in the public relations department for about thirty years. The *Sentinel*'s John Abberley once wrote that it was a standing joke among journalists that it was difficult even to get Dennis to admit that Michelin made tyres. He became the editor of the Michelin house magazine, *Bibendum*. However, he had a wide range of other interests including poetry, swimming and singing. He died in 1995.

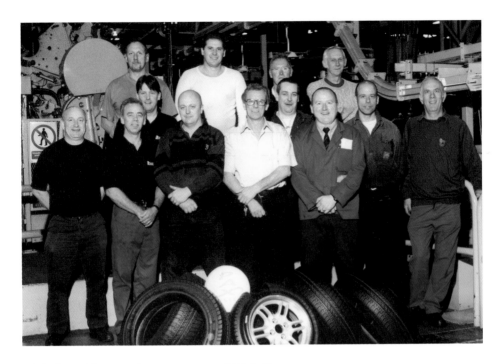

Michelin Rubber Workers, *c.* 1999, and Michelin, 2013
Bob Adams, who is seen on the extreme right of this photograph, joined Michelin in 1964 and finished in 2001, aged fifty-six. He worked in the quality control department. His memory of starting is that there were no directional signs on what was a large site. However, there were areas known to employees as Chester Road, Birmingham Road, Bolton Road and London Road. He also recalls that it was a very secretive workplace, as Michelin were very wary of industrial espionage.

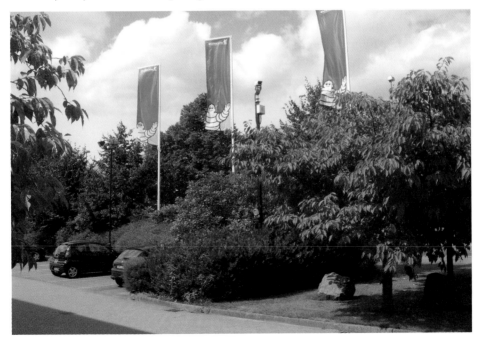

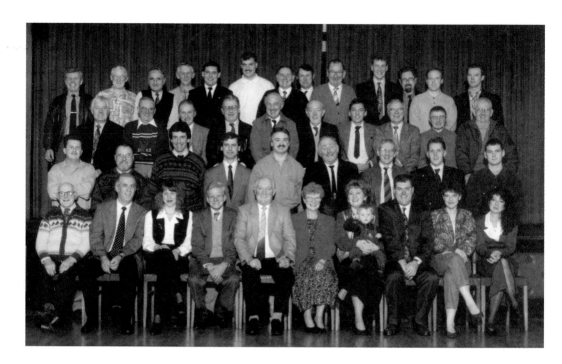

Michelin Retirement Function, *c.* 1999, and Michelin, 2013

What was it like to work at Michelin? Bob Adams remembers: 'Wages and pensions were good, and a lot of colliers left the pit to come and work at Michelin. Overtime was usually available, there was sick pay and they would take you home in a taxi if you hadn't got a car. There was a terrific welfare service with sports facilities, a club house with a nearby rifle range. It had a library and a cinema where training films were shown.'

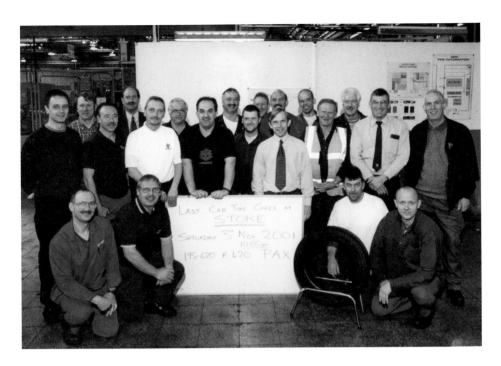

Michelin, 2001, and Paul Niblett, 2013

Bob continues: 'You were given free overalls, donkey jackets, and boots. After six months of employment you received free pushbike tyres, and after three years, free car tyres – and they would fit them for you. When you had worked for thirty years, as I did, you were given free tyres for life. Michelin had its own safety officers, doctors and nurses. They really valued workers.' Paul Niblett is another former employee, who has written much on the history of the company.

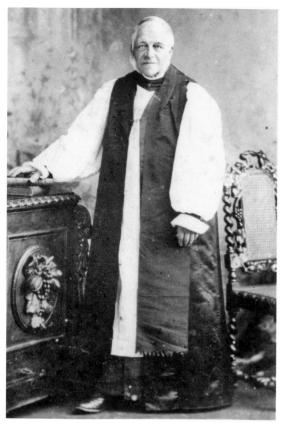

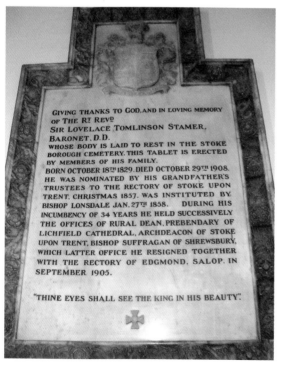

Sir Lovelace Stamer, Date Unknown, and Memorial, 2013

Our section on the church of St Peter ad Vincula begins with a photograph of an important Anglican bishop, and a memorial to him that is displayed in the edifice. Lovelace Tomlinson Stamer was born 18 October 1829 and died on 29 October 1908. He succeeded his uncle, J. W. Tomlinson, as rector of Stoke-upon-Trent in 1858, holding the position for the next thirty-four years. He was vice president of the North Staffs Infirmary committee, and a trustee for nearly fifty years. Among his many achievements in Stoke was his establishment of Sunday schools in Cliff Vale, London Road, Mount Pleasant and the Mount Estate. Something of a latitudinarian, he permitted nonconformists to serve as pupil teachers in the schools. Another measure of Stamer's influence in Stoke was seen in 1875. At the request of Stamer and a few nonconformist ministers, the principal vaults and public houses of Stoke were closed one evening, with the aim of giving the pub assistants the chance of attending mission services. St Peter's service ran from 6.30 p.m. until 9 p.m. on that night, and it was reported that 'every seat in the church was occupied, and many persons contented themselves with standing'. Another plaque in the church declares that L. T. Stamer was rector of the parish between 1858 and 1892, archdeacon and rural dean of Stoke-on-Trent, and suffragen bishop of Shrewsbury. The plaque adds that 'as he desired that no public memorial should be raised to him, this tablet has been erected by a few private friends, that his memory may be honoured in the place which he served so long and faithfully'.

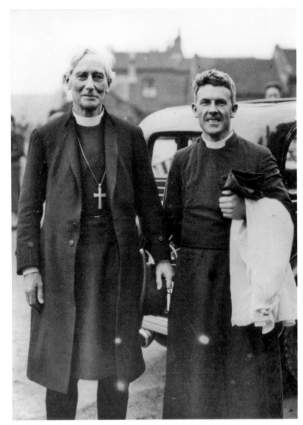

Bishop Woods and Percy Hartill, Date Unknown, and St Peter's, 1994
The Revd Percy Hartill became rector and archdeacon of Stoke-upon-Trent in 1935, succeeding the Right Revd Douglas H. Crick. For years, he was a familiar figure in the Stoke district, as he cycled in his gaiters round his large parish. He is pictured here with Bishop Woods. During the Second World War, Hartill nurtured an anti-war stance – and in 1949, he controversially refused to permit St Peter's to be used for a Battle of Britain service. He resigned from his post in 1955, after suffering a stroke. He died in 1964, loved by believers and non-believers for his great humanity. The Percy Harthill memorial chapel inside St Peter's is used as a chapel of prayer for peace and justice around the world.

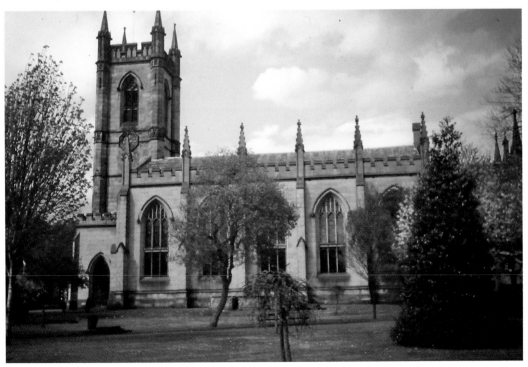

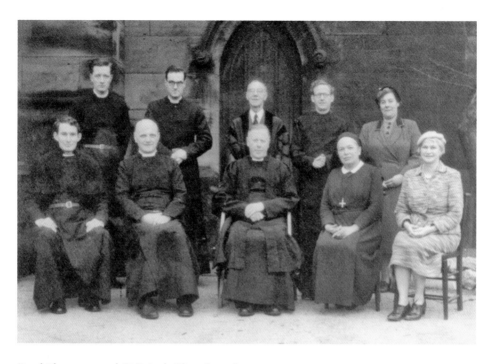

Revd Chapman and St Peter's Churchyard, 2013

Frederick Alexander Routley Chapman was rector of Stoke between 1956 and 1966. Here he is pictured with staff. From left to right, back row: John Linford, Wm Henry Ball (verger), Mrs Agnes Ruscoe. Front row: Blake Harrop, F. A. R. Chapman, Deaconess Irene Smee and Miss Emmie Brandall (secretary). The lower photograph shows the path leading to the west door from Glebe Street.

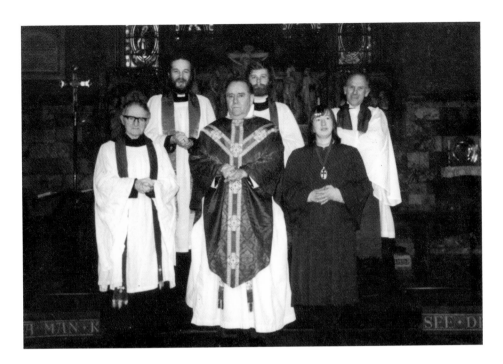

Revd Cason and St Peter's Volunteers, 2013

Alan Gilbert Foster Barker was rector between 1966 and 1974, followed by Ronald Arthur Cason (1974–1991). The volunteers below, providing a warm welcome to visitors to Stoke Minster, are Win Grocott and Brenda Heeks. The decision to extend opening hours was influenced by Stoke Minster's position at the mid-point of the new Two Saints Way pilgrimage, and by the display of Staffordshire Hoard items in the Potteries Museum.

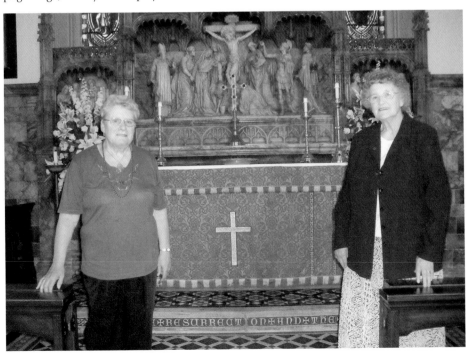

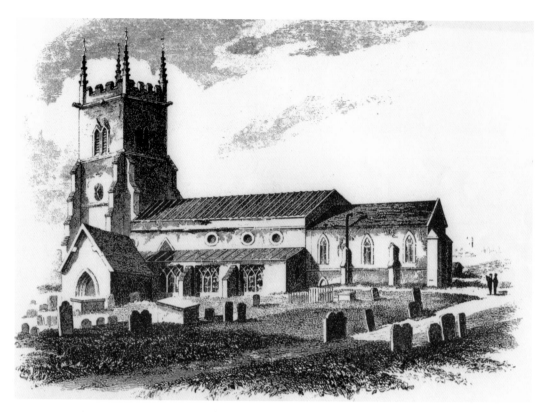

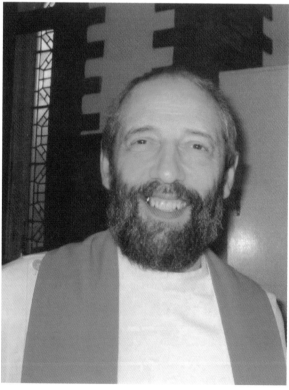

Stoke Old Church, c. 1824, and Revd Ruddock
The church of St Peter ad Vincula can trace its origins to a modest Saxon church. As late as the mid-eighteenth century, there were very few houses in the vicinity of the church. The top illustration shows St Peter's as it looked before the new – and present – church was erected (consecrated in October 1830). The old church consisted of an aisled nave, a three-bay chancel, a west tower, a south porch and a north vestry. Parts of the ancient church were embraced in a major rebuild in the early thirteenth century. The three-stage tower seen here was surmounted by crocketed pinnacles, and dated from the fourteenth century. There were sundry other alterations prior to the construction of the present church, which began in 1826. Edgar Chapman Ruddock, seen here, was rector between 1991 and 2002.

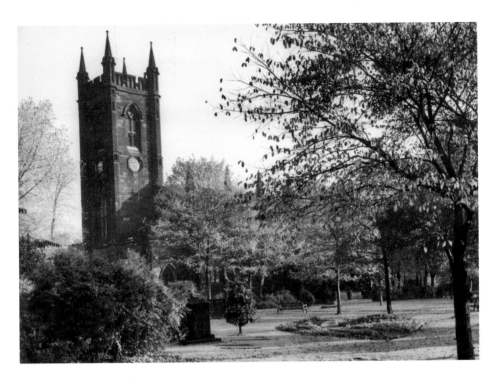

St Peter's Churchyard, Date Unknown, and 2013

The new St Peter's church was designed by Trubshaw and Johnson, of Haywood, in the English architectural style of the thirteenth and fourteenth centuries. The tower has an embattled parapet, and the church, of Hollington stone, is heavily buttressed. Its huge size meant that it was suitable for choral events such as the Stoke-upon-Trent Grand Music Festival of 1833, which raised funds for the benefit of the North Staffordshire Infirmary.

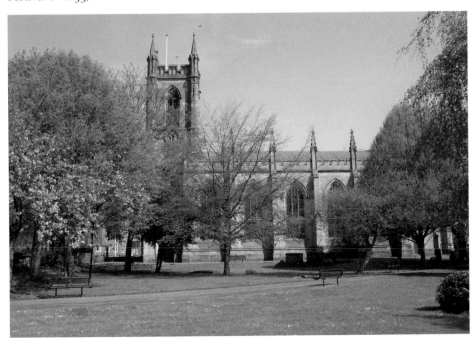

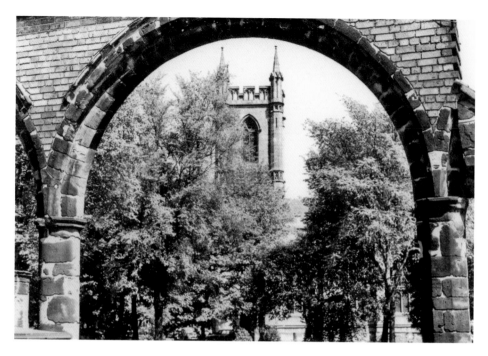

St Peter's Through the Arches, Date Unknown and 2013

The 112-foot-high tower of St Peter's is seen through one of the arches, re-erected by Stoke architect Charles Lynam (1829-1921) in the 1880s. Below this reconstruction, the grave of master potter Josiah Wedgwood (1730–95) can be found. In 1991, the arches were cracking and threatening to collapse on to Josiah's grave. Their subsequent renovation was funded by English Heritage, Stoke City Council and the Moat House Hotel in Etruria, which is attached to Wedgwood's old home.

St Peter's Event at the King's Hall, Date Unknown, and St Peter's Tower, 2013

In 2005, St Peter's was officially designated a Minster, recognising it as the largest and most important in the city, and the venue for services of public importance. It was chosen as the venue for Stanley Matthews' funeral in 2000. Prebendary David Lingwood told the *Sentinel* in 2010: 'The Minster church of St Peter ad Vincula is a living link with our Saxon past, yet it is not a museum but an active and growing congregation.'

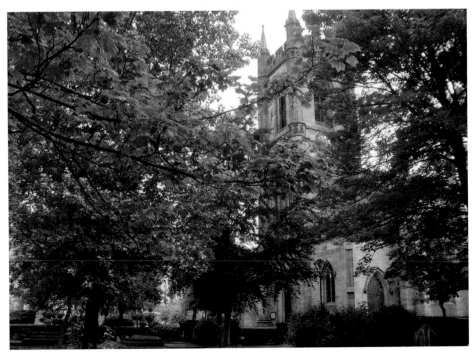

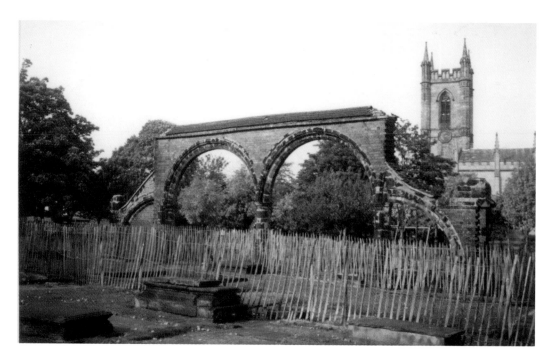

St Peter's Churchyard, 1991 and 2013

Much of the stone from the old thirteenth-century church was sold off during the erection of the 1829/30 church. Some was used to form the bed of a watercourse serving Boothen Mill. In 1881, the mill was demolished, and Charles Lynam rescued the stones from the bed of the watercourse, which was about to be filled in. He then rebuilt the piers, responds and arches of the thirteenth-century church in Stoke churchyard in 1887 – an interesting feat of conservation.

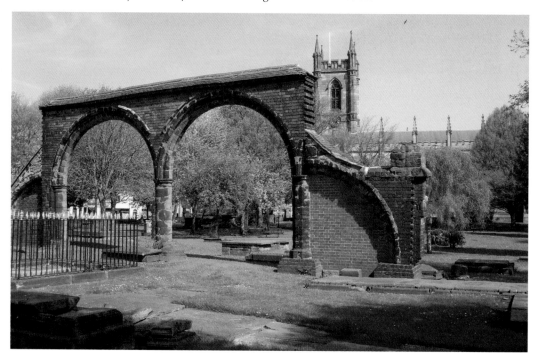

Old Wesley Methodist Church, 1983, and Present Church, 2013
The demolition of the above building in 1983 was followed by the removal of the Wesleyan Methodists into the building seen below. Its four foundation stones – laid on 12 May 1956 – can still be seen today. This was opened as the Youth Centre on 26 January 1957. One of its aims was to encourage more children to attend what was known as the 'Junior Church', but the initial response was disappointing.

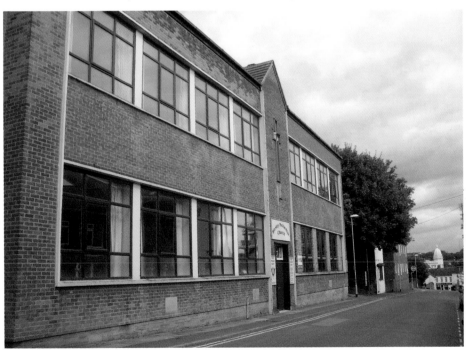

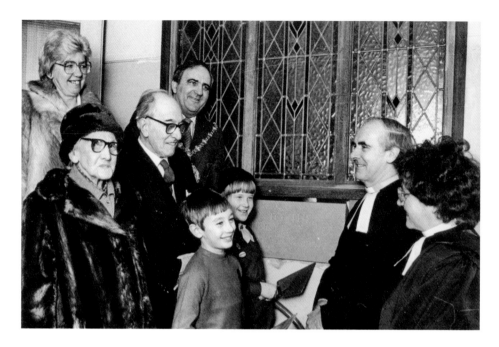

Opening of New Church, 1985, and the Prophetts, 2013

The Youth Centre came to house the Wesley Methodist church from 1985, following alterations. Today, we would wonder why the old 1816 church was not listed. The truth is that it had been examined by City Council officers and was on the verge of being spot-listed, just before the demolition was hurried through by the church council, which was keen to vacate the deteriorating building. Church members Maureen and Norman Prophett are pictured.

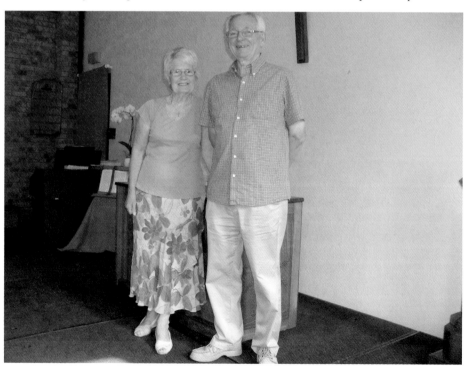

Opening of New Church, 1985, and Corky's, 1998

The new church has served the Wesleyans well since 1985, but church members are about to move once again. Following the sale of Trent Vale Methodist church for about £200,000 in 2011, its congregation moved to the Epworth Street church, creating the newly titled Stoke Methodist church. However, the old pub – traditionally known as the West End Inn – has now been purchased, and upon its renovation it will provide a more central and accessible base for the local community.

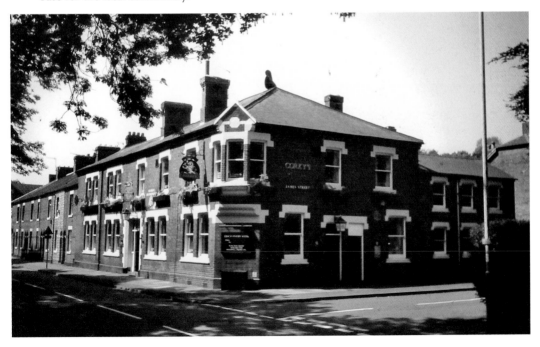

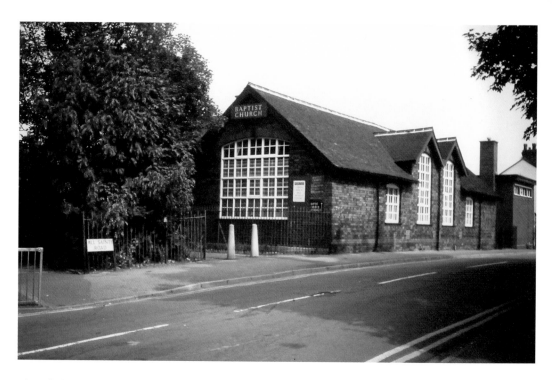

Site of the Baptist Church, 1995 and 2013

We now visit a location that is but a short distance from the West End Inn. Stoke Baptist church, with its traditional pitched roof, stood near the end of All Saints Road, but has now been demolished. The site is presently being redeveloped.

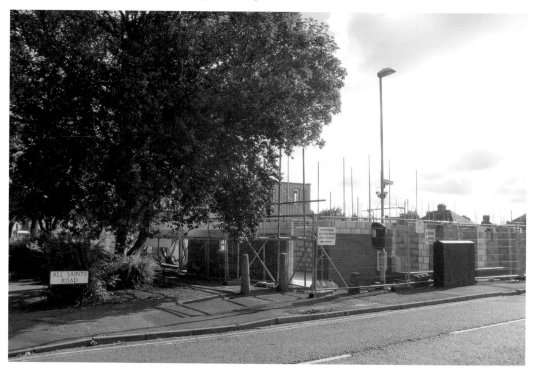

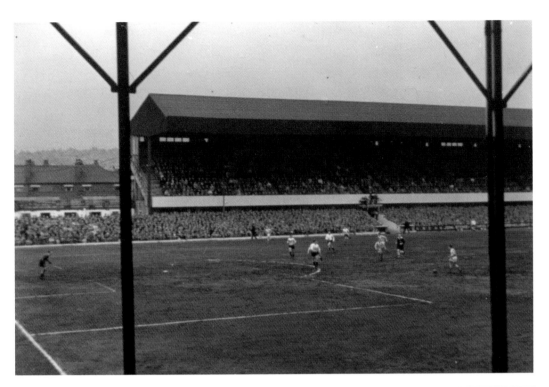

Stoke City *v.* Luton, 1962/63, and Supporter, 2011

Stoke City's greatest ever player, Stanley Matthews, first played for them against Bury in the 1931/32 season. Despite several rows with the Stoke management, he never wanted to leave – but having business interests in Blackpool, he transferred to that club in 1947. He returned to Stoke City in 1961 and the season after, Stoke launched a challenge for promotion from Division Two. The following photographs depict Stoke versus Luton at the Victoria Ground in May 1963. Stoke, gunning for promotion, fielded the following team: O'Neill, Asprey, Allen, Clamp, Stuart, Skeels, Matthews, Violet, Mudie, McIlroy, and Ratcliffe. The bottom photograph shows City supporter Cliff Proctor outside the present Britannia Stadium, before the Europa League match against Hajduk Split in 2011 (Stoke won 1-0).

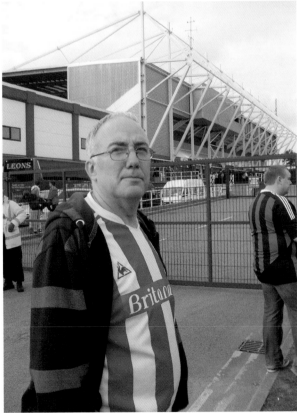

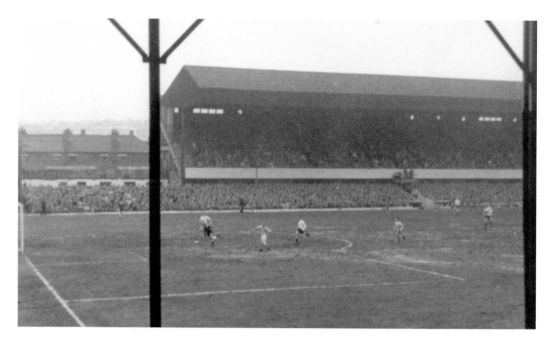

Stoke *v.* Luton, 1962/63, and Stoke Supporters *v.* Hajduk Split, 2011

Stoke's pitch had been watered and was muddy in parts prior to the Luton match. Mudie's thirty-third-minute goal eased Stoke's nerves against the Hatters, who themselves needed the points as they were fighting relegation. The *Sentinel* reports the story of what happened after half-time: 'The ball was lobbed down the field following a Luton attack by McIlroy, and Matthews was there in the middle with the Luton defence wide open to take the ball through...'

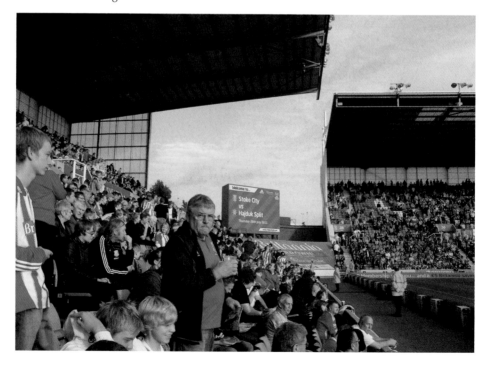

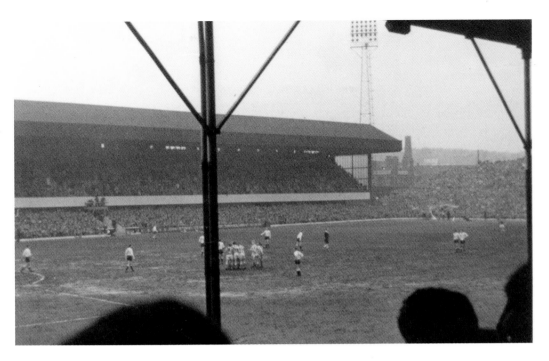

Stoke *v.* Luton, 1962/63, and Stoke Supporters *v.* Besiktas, 2011

'...As he was challenged, Stan veered over towards the left to take the ball wide of the goalkeeper as he came out, and then carefully crossed it over the line. He was mobbed by his colleagues, and the crowd's standing ovation echoed and re-echoed around the ground with a din which must have been heard in nearly all the Six Towns.' It was Stan's first goal of the season! The lower photograph shows supporters Jordan Ridge and Patrick Proctor.

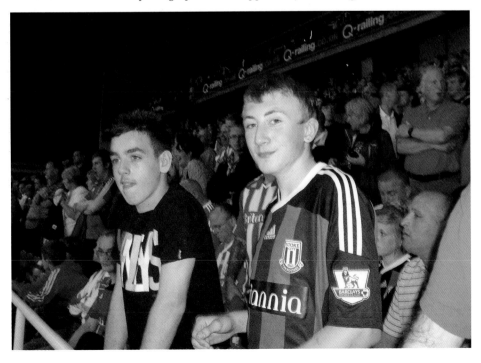

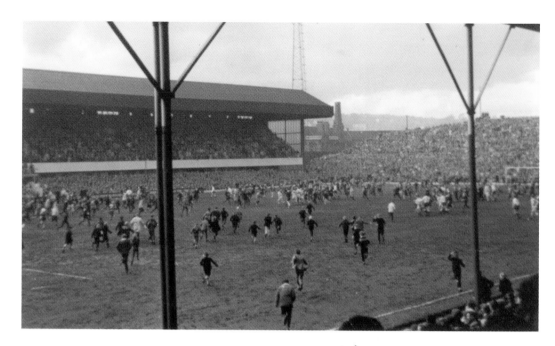

Stoke *v.* Luton, 1962/63, and Matthews Statue, 2013

The delight of the crowd after the game is seen here. The attendance that day was 33,644. Stoke were promoted as champions. The legendary *Sentinel* columnist John Abberley watched the game and later wrote: 'By then, Stan was forty-eight, but he ran through the defence like a teenager.' Matthews retired in 1965, being fifty years and five days old when he played against Fulham. The three-figure statue of Stan is located outside the Britannia Stadium.

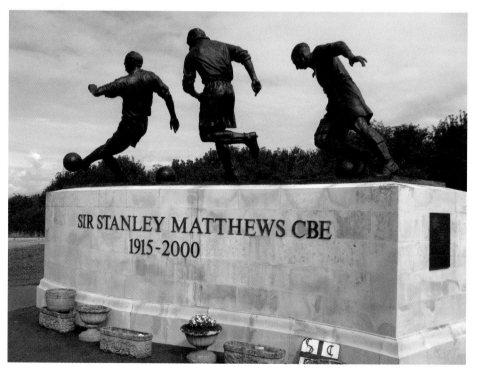

SIR STANLEY MATTHEWS CBE
1915-2000

Stanley Matthews, Date Unknown, and Stan Waxwork, 2013

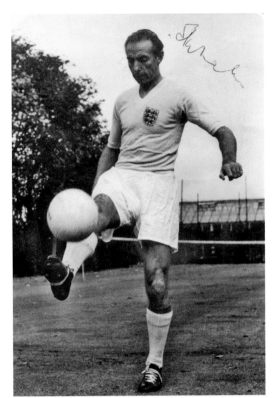

The waxwork figure of Stan in Madame Tussaud's (Blackpool) reminds us of his spell with Blackpool. The Seasiders paid £11,500 for him in 1947. Stan later recalled, 'I was thirty-two – getting on a bit for a footballer, I suppose – and there were those who thought I was almost finished. But Blackpool did not even ask for a medical. They just wanted me and I remember the manager, Joe Smith, asking me if I thought I could manage a couple of seasons for them.' Stan trained each day on Blackpool beach, the sea air aiding the deep breathing exercises of this fitness fanatic. In 1948, he was voted Player of the Year by football writers. He went on to make 379 appearances for Blackpool, playing in three FA Cup finals over fourteen years. One of the Wembley finals was the still-remembered 'Matthews Final' of 1953, when Stan, aged thirty-eight, inspired Blackpool, who were 3-1 down, to a 4-3 victory against Bolton Wanderers. Neutral supporters across the country had prayed for a Blackpool victory, as Stan had collected loser's medals in his previous two finals. Jimmy Armfield, who played for Blackpool and England, told the *Sentinel* in 2000: 'You could kick him and do anything with him and he would never retaliate. He was the perfect example of self-discipline. I never remember a referee speaking to him once – and he didn't speak to them, either.' Matthews was never cautioned or dismissed. He died on 23 February 2000 at the age of eighty-five, but a bronze statue of him can be seen in Parliament Row in Hanley. The work of sculptor Colin Melbourne, it was unveiled in 1987, depicting Matthews at the age of forty-six. In the 1990s, pranksters stole the bronze football from between Stan's feet on two occasions.

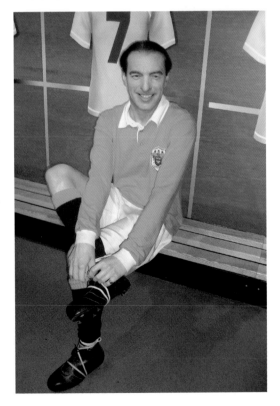

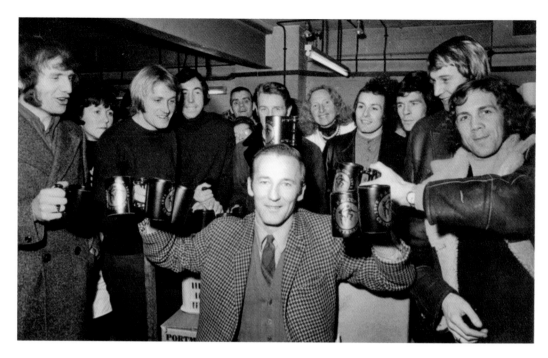

Peter Dobing and Stoke City Teammates, 1972, and Stoke *v.* Genoa, 2013
Peter Dobing (centre) forged new interests in pottery wholesaling after his playing career
came to an end. Born in Manchester in 1938, he played for Stoke between 1963 and 1973.
Manager Tony Waddington signed him from Manchester City for £37,500. An inside
forward, he was later moved into midfield by Waddington. Dobing was the captain of Stoke
City's 1972 League Cup winning team. The bottom photograph was taken at a close season
friendly at home to Genoa of Italy.

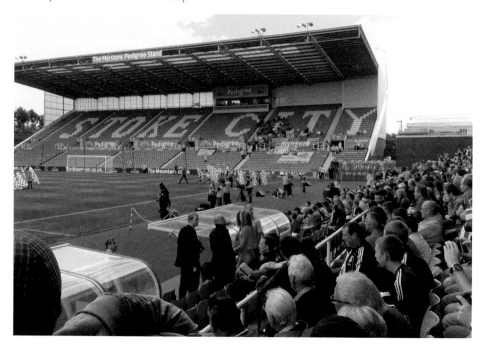

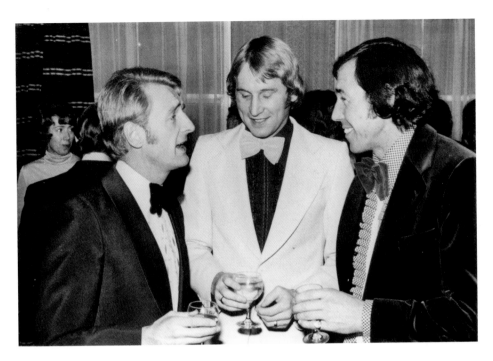

Eastham, Smith and Banks, Early 1970s, and Stoke *v.* Genoa, 2013

George Eastham, pictured with Stoke City teammates Denis Smith and Gordon Banks, played for Newcastle United, Arsenal and Stoke City. An inside-forward/midfielder, he was a non-playing member of England's 1966 World Cup winning squad. Eastham scored the winning goal for Stoke in the 1972 League Cup final. At the age of 35 years and 161 days, he was the oldest player to receive a winner's medal at that time. The Stoke City versus Genoa match ended o-o.

Gordon Banks and Family, Early 1970s, and Stoke *v.* Genoa, 2013

Gordon Banks was born in Sheffield in 1937. He made his Stoke City debut in April 1967, having signed from Leicester City for £52,000. He made a total of 246 appearances for Stoke, 194 of which were in the League. His last game for Stoke was in October 1972. Gordon won seventy-three full England caps, and was goalkeeper in the World Cup final of 1966 when West Germany were beaten 4-2.

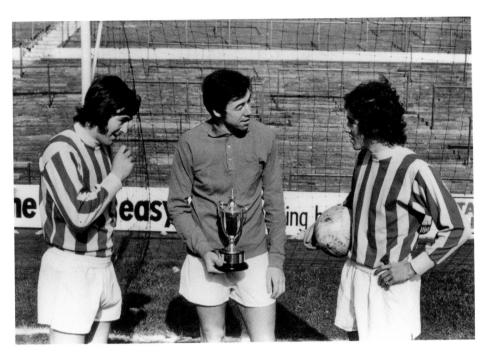

Gordon Banks and Teammates, Early 1970s, and Stoke *v.* Genoa, 2013
Upon signing for Stoke, Banks gave an interview alluding to manager Tony Waddington's policy of signing veteran players: 'I've not come here to retire, you know. I've come here to win something.' His last full cap came in 1972, when England beat Scotland 1-0 at Hampden Park. He kept thirty-five clean sheets in seventy-three appearances and was on the losing side only nine times.

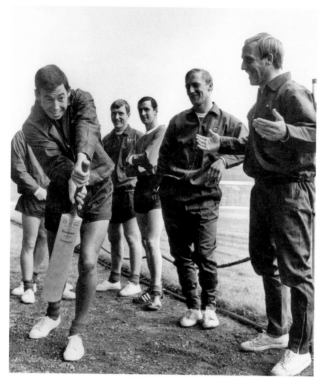

Gordon Banks With Bat, Early 1970s, and Stoke v. Genoa, 2013
Banksy proves handy with a cricket bat at this press call. Younger supporters may have seen archive footage of an odd incident involving England's Banks and Northern Ireland's genius winger George Best on 15 May 1971. During this international match, Best cheekily flicked the ball out of the goalkeeper's hands and headed it into the net. The 'goal' was disallowed by the referee, who judged Best to be guilty of dangerous play. On the subject of Gordon's England career, it should be noted that he sold his England World Cup winner's medal at Christie's for £124,750 in 2001. His cap from that glorious game was also sold for £27,025.

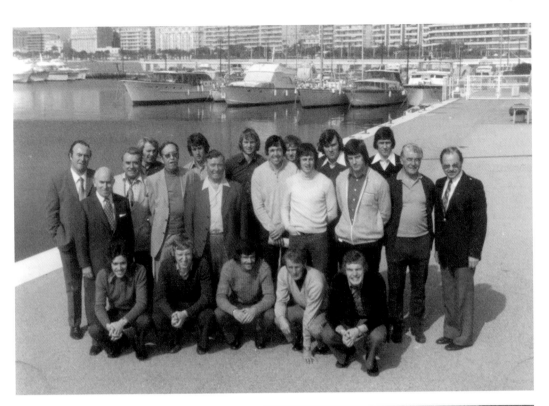

Stoke City in Cannes, Early 1970s, and John Ritchie Bust, 2013

Big John Ritchie (1941–2007) is seen on the extreme right of the back row, with the large shirt collar. He was born in Kettering, and played for Kettering Town before being recommended to Stoke City manager Tony Waddington. He moved from Northamptonshire in 1962. His wife, Shirley, cried on the way, but they settled happily in the Potteries. John made his professional debut in April 1963. Stoke were promoted from the old Second Division a month later. In his first top-flight season, Ritchie scored thirty goals. Despite scoring another thirty goals in forty-seven appearances in his third season, he was transferred to Sheffield Wednesday for £70,000 in 1966. There, he made eighty-nine appearances and scored thirty-four goals. He rejoined Stoke in 1969 for £25,000. He led the attack until 1974, when he sustained a double fracture to his leg. He scored an impressive 171 goals in 343 competitive matches for Stoke.

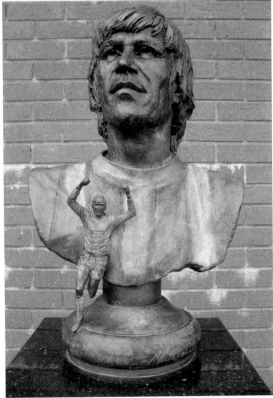

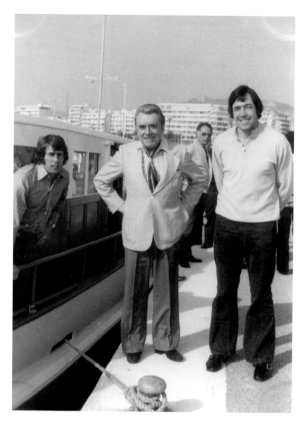

Stoke City in Cannes, Early 1970s, and Stoke _v._ Genoa, 2013
In the 1972 League Cup semi-final, Banks and Geoff Hurst (left) were pitted against each other in the most dramatic circumstances at Upton Park, West Ham. Hurst's penalty kick was brilliantly tipped over the crossbar by Banks. It was a key moment during Stoke's march to glory and a 2-1 victory against Chelsea in the final. Hurst played for West Ham between 1959 and 1972 (411 appearances, 180 goals), before a spell at Stoke between 1972 and 1975 (108 appearances, 30 goals).

Gordon Banks Testimonial, 1973, and Stoke v. Genoa, 2013

Gordon was involved in a car crash in 1972, on the way back from a session with the club physiotherapist. He lost the sight of his right eye and ultimately was forced to retire from top-flight football. His testimonial match on 12 December 1973 saw Stoke City playing Manchester United. Our photograph shows Eusebio of Portugal, who guested for United, and Gordon's former England teammate, Bobby Charlton of Manchester United. Gordon was named Football Writers' Association Footballer of the Year in 1972, and was named as FIFA Goalkeeper of the Year on six occasions. The International Federation of Football History Statistics, formed in 1984, rated Banks the second-best goalkeeper of the twentieth century, behind Russia's Lev Yashin.

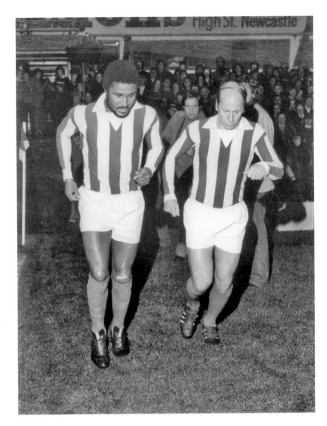

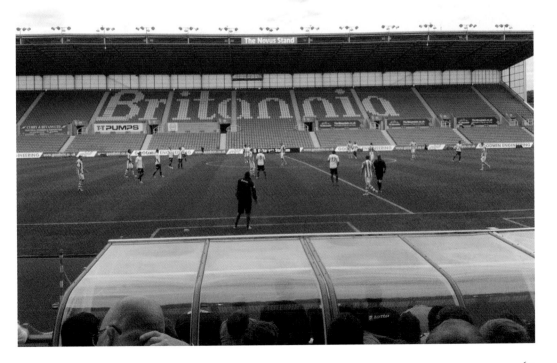

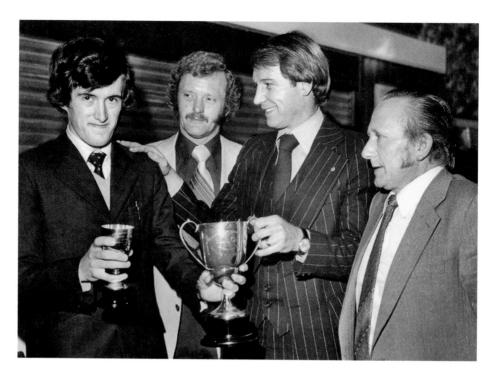

Denis Smith, 1981, and Britannia Stadium, 2013

Denis Smith, seen here presenting the author with a crown green bowling trophy at Wolstanton WMC, was born in Meir in 1947. Between 1968 and 1982 he played nearly 500 games for Stoke City, ending his playing days with York City. A tough centre-half, Denis suffered broken legs on five occasions, a broken nose (four times), a cracked ankle, a broken collar bone, a chipped spine, broken fingers and toes, and needed more than 200 stitches in his playing career.

Site of Victoria Ground, *c.* 1984 and 2013
The Victoria Ground was Stoke's home ground from 1878 until 1997, when the club relocated to the Britannia Stadium. The first match at the old ground was against Talke Rangers, in March 1878 – Stoke winning 1-0, in front of 2,500 fans. The first football league game was on 8 September 1888, against West Bromwich Albion. In 1937, a First Division game against Arsenal drew a crowd of 51,373. Floodlights were installed at the ground in 1956.

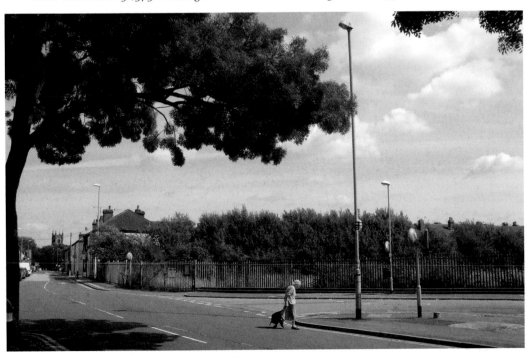

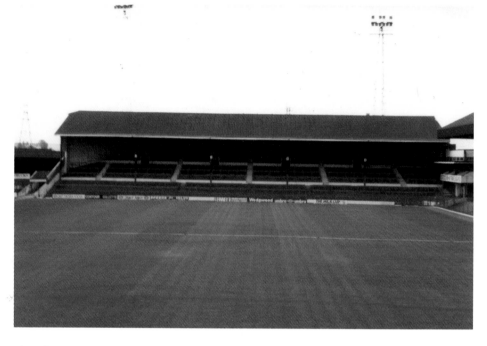

Site of Victoria Ground, *c.* 1984 and 2013

The ground witnessed numerous thrilling games, including a 10-3 romp against West Bromwich Albion in 1937. Less pleasing was a 10-0 defeat by visitors Preston North End in 1889. In 1957, Stoke's Neville Coleman scored seven goals for Stoke against Lincoln City, a record for a winger in English senior football. Then there was Stoke's 3-2 victory over Leeds United in 1974, which brought the away team's twenty-nine-match unbeaten run to an end.

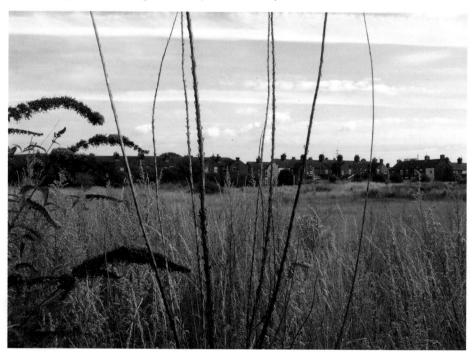

Site of Victoria Ground, *c.* **1984 and 2013**
During demolition work on the Victoria Ground in November 1997, a Stoke City shield – measuring 6 by 4 feet – that once hung on the *Sentinel* Stand, was purchased and displayed by the landlord of the Victoria pub, which stood opposite the ground. Following the departure of Stoke City FC, St Modwen purchased the land, which remains (in 2013) overgrown with weeds.

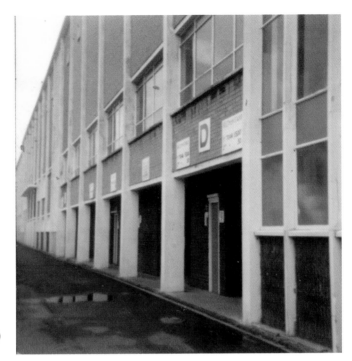

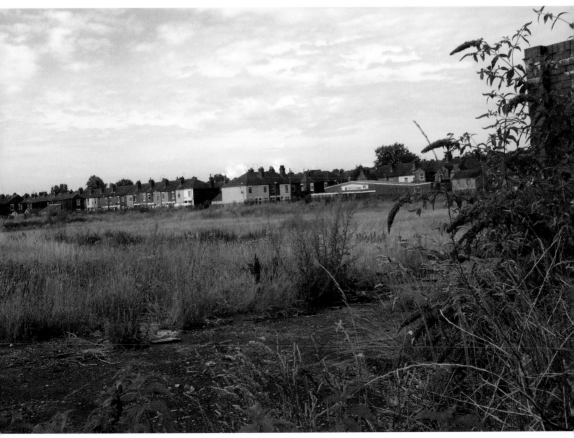

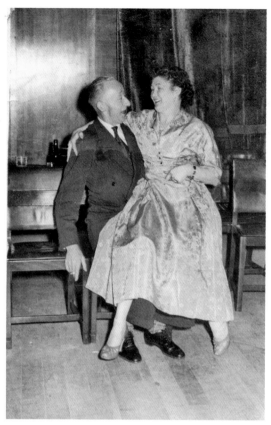

Dancing at the King's Hall, 1955, and King's Hall, 1994

The King's Hall dances were very popular in the 1950s, when this photograph was taken. It shows Mr Mellor and Mrs Marie Haywood at the Whieldon Sanitary Pottery dinner dance. One local man who provided entertainment in those days was the 'Legendary Lonnie', whose rock and roll, rhythm and blues band would appear as a novelty act. Lonnie told the *Sentinel* in 1992: 'I often wonder how anyone heard us, we didn't have amplifiers or powerful microphones. There were sometimes more than 3,000 in the King's Hall. At 10 p.m. people would still be queuing, waiting for people to leave, so that they could get in.'

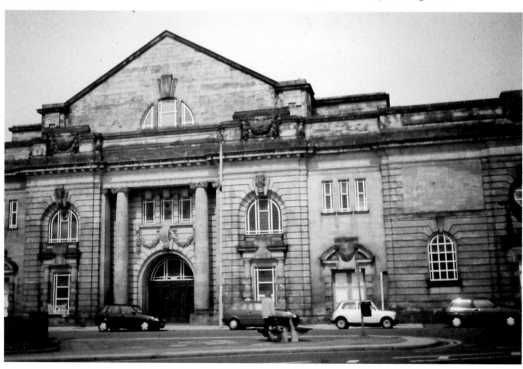

Red Lion on Architect's Plan, 1903, and at Crich, 2001

It is certain that the Red Lion existed in medieval times in a different, primitive form. The Stoke architect Charles Lynam was stating the obvious in an address he gave in 1905, when he observed that 'it was a common kind of provision to place an inn near to the church for the accommodation of those who attended long distances'. The date of the plan shows that the pub was rebuilt in this florid style in Edwardian times.

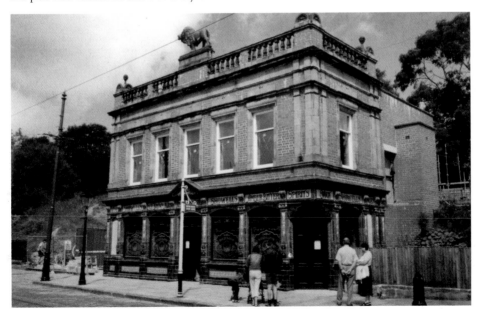

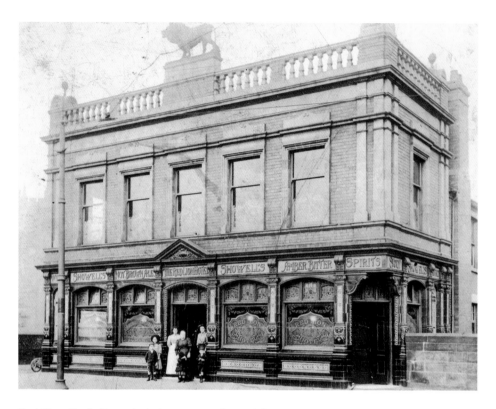

Red Lion, Early Twentieth Century, and at Crich, 2002

The Red Lion stood on Church Street, Stoke, on the south-east corner of St Peter's churchyard. It benefited from its position, overlooking the Newcastle to Derby road (turnpiked in 1759) and would have been well-known to travellers. The premises in 1831 incorporated a blacksmith's (no doubt very convenient for those travelling by horse-drawn transport on the turnpike road), stabling for thirty horses and a malthouse.

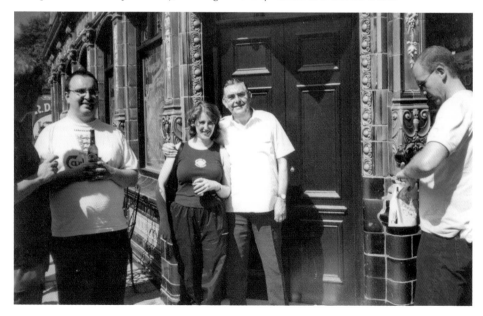

Red Lion Window, Date Unknown, and 2001
The Red Lion had close connections with the local tramway system. The North Staffordshire Tramways depot stood across Church Street. A fatal accident took place in 1882, when a lad named Arthur Chesworth, trying to jump on to the front step of the Stoke to Longton tram, missed his footing and fell beneath the wheels. Death was almost immediate, and the boy, according to reports, 'only breathed twice' before expiring. The inquest was held at the Red Lion.

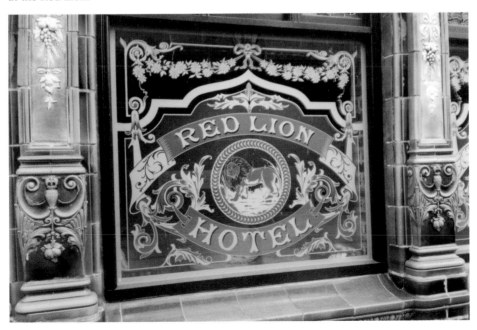

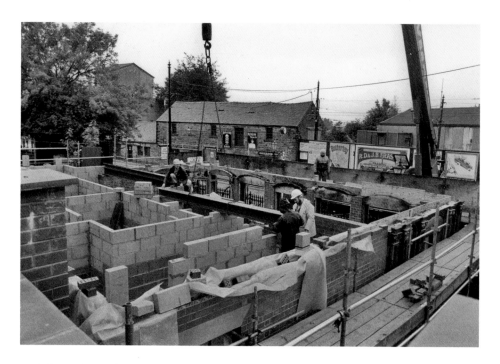

Red Lion Being Rebuilt and in 2002

In 1973, the inn was purchased by compulsory order from Ansells brewery, subsequently dismantled brick by brick and transported to the Crich Tramway Museum in Derbyshire. Work on the reconstruction did not begin immediately, but by 2001 the pub had virtually been reconstructed, apart from the interior. The colour photograph shows a Burslem History Club trip to Crich. Pictured are John Field (in the purple shirt), Craig and Sarah Bridgwood, and Harold Harper.

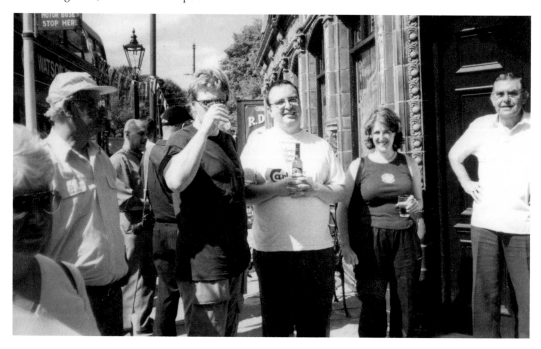

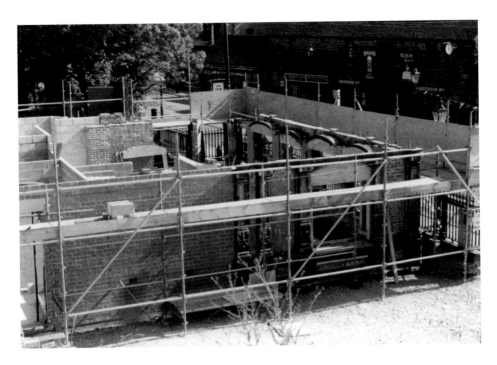

Red Lion Being Rebuilt, c. 1996 and 2002

The architect primarily responsible for the pub's reconstruction was Jim Soper, assisted by a team of volunteers. The present Red Lion is a fibre-glass version of the old. Derek North, the last landlord of the pub, travelled from his Plymouth home to cut the ribbon at the reopening in 2002. The building is a café-cum-bar and an overspill education area for school parties. The lower photograph shows Mervyn Edwards about to give a talk on the building's history to History Club colleagues.

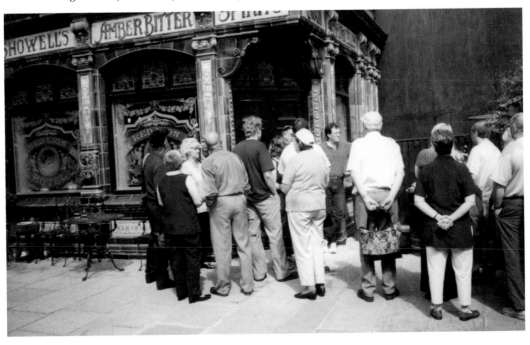

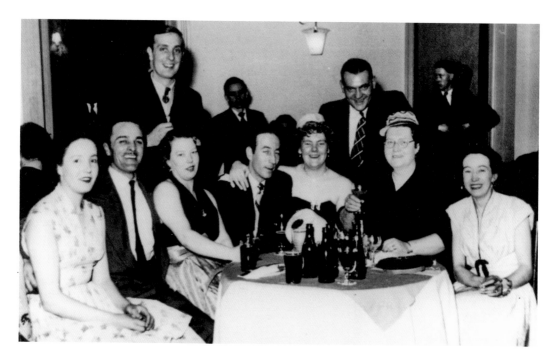

North Stafford Hotel Staff Christmas Party, *c.* **1953, and North Stafford Hotel, 2013**
Charles Knight, an observer writing in the 1840s, commented that Stoke's railway hotel 'is built precisely in harmony with the station itself; and with its stables and out-houses, has the appearance of an old English mansion of the larger kind ... as seen from the gravelled quadrangle between the station and the hotel, there is an architectural unity in the expression of the whole, which will yield to very few things of the kind in the kingdom'.

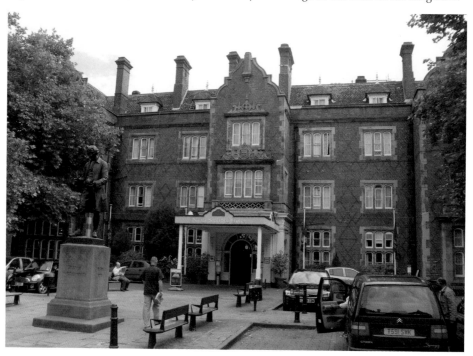

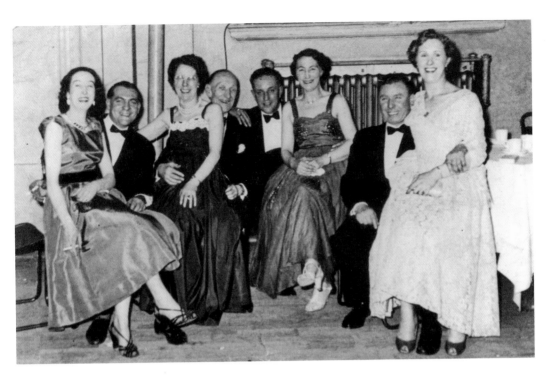

North Stafford Hotel Party, Late 1950s, and North Stafford Hotel, 2013
From the time of its opening in 1849, the North Stafford Hotel established itself as the foremost venue for meetings and social events in the area, superseding the revered Swan Hotel in Hanley, which had been a high-profile rendezvous point for businessmen and others, until its demolition in the 1840s. From left to right in the top photograph are: Flo Baddeley, Albert Baddeley, Mrs Pointon and Lou Pointon, -?-, -?-, Percy and Doris Axon.

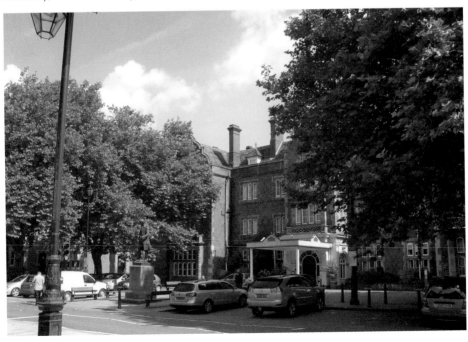

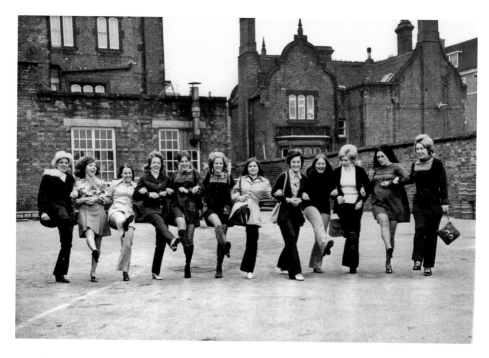

North Stafford Hotel (Rear), Early 1970s and 2013

In the 1860s, the hotel welcomed the North Staffordshire Coal and Ironstone Masters' Association, the North Staffordshire Medical School, and the North Staffordshire Naturalists' Field Club, among other societies. The connection with the coal and ironmasters probably explains why the hotel was considered a suitable venue for a public meeting following the colliery disaster at Talke in 1866, when ninety-one men were killed. The wives and partners of Stoke City players appear at the rear of the hotel in the top photograph.

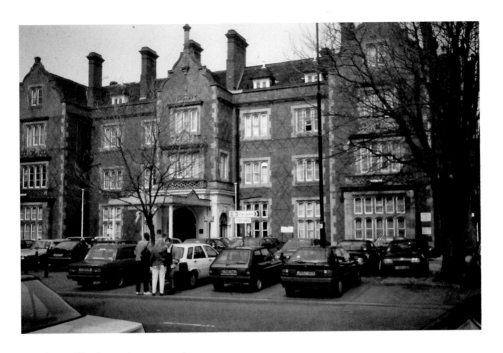

North Stafford Hotel, 1994 and 2013
The hotel has a close connection with local cricket, for in October 1884, members of the
Staffordshire County Cricket Club met there and decided to establish a county cricket
ground at Stoke. This was duly achieved, and from the mid-1880s the hotel welcomed
visiting international cricketers, the County Cricket Club's ground being situated to the rear
(now occupied by university buildings). The Australian tourists visited Stoke three times
between 1886 and 1890 to play an English XI.

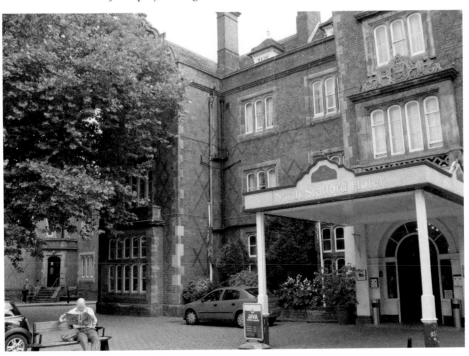

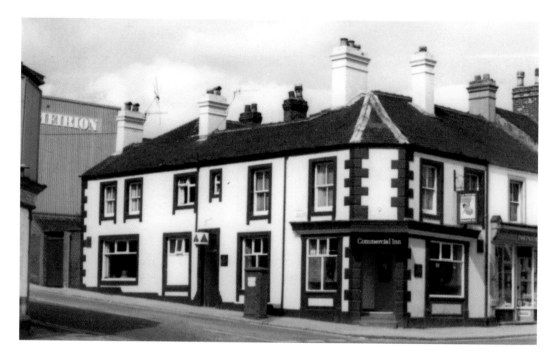

Commercial Inn, *c.* 1981 and 2013

When the Commercial Inn beerhouse in London Road was up for sale by auction in 1868, it was described as having a stable, brewhouse, malthouse, piggery and yard adjoining. It was situated next door to a butcher's shop and slaughterhouse. Further up the road, Portmeirion can be seen. Other surviving pubs along the Stoke section of London Road include the Sutherland Arms and O'Leary's (formerly the Vine).

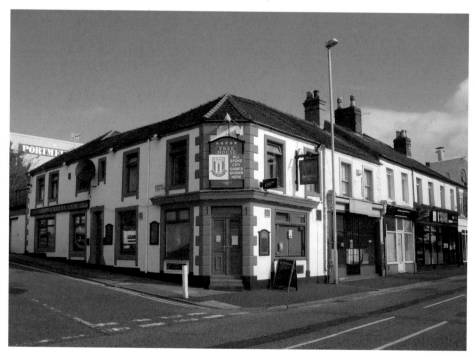

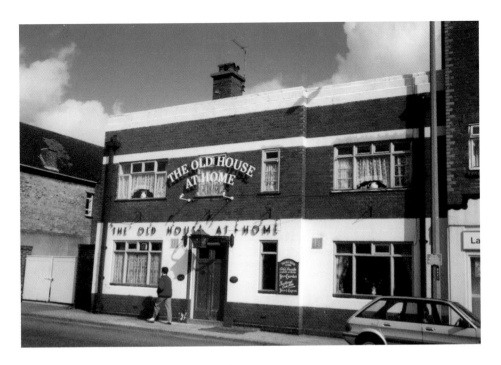

Old House at Home, Hartshill, 1991 and 2013

Around 1867, Samuel Stonier, a coal dealer, was granted a beerhouse licence for the original terraced house. Like many beerhouses in Hartshill, it had a slightly insalubrious reputation, appearing in the local police court reports in 1874 on account of its connection with prostitutes and for an assault by the beer seller himself in 1881. The Hartshill conker championships have been held at the present pub, which has a lounge to the left and a bar to the right.

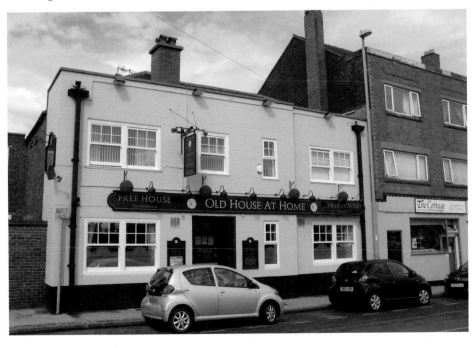

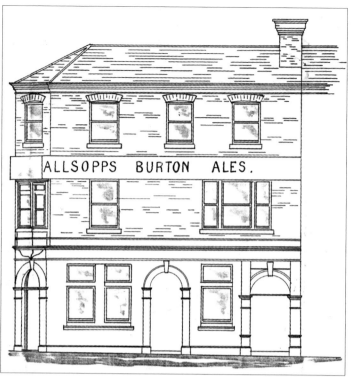

Gordon Hotel on Architect's Plan, 1903, and the White Star, 2009

The White Star pub boasts mock-Victorian cosy corners that are ideal for an intimate chat or a romantic tryst. The pub was not exactly short of them in 1903, according to an architect's plan in the author's archives. Back then, it was known as the Gordon Hotel and had a smoke room, a vaults, a saloon bar, a wine bar and the grandly named Windsor room, all on the ground floor. The Potteries Pub Preservation Group pose outside in 2009.

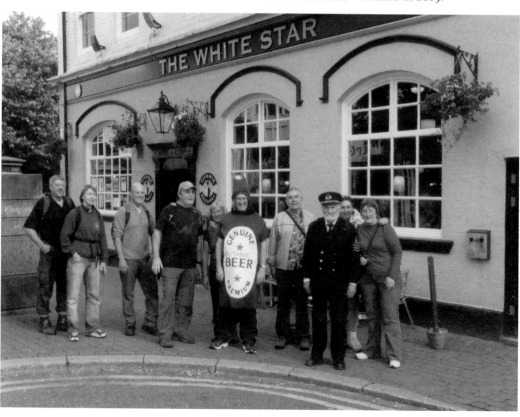

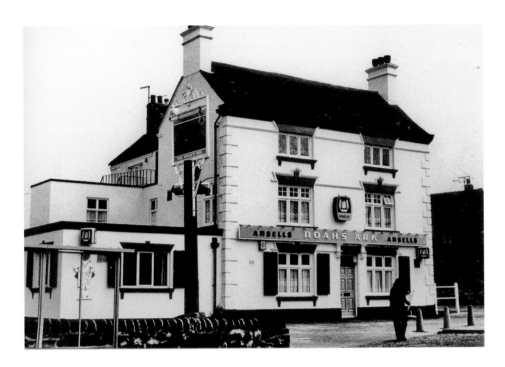

Noah's Ark, Hartshill, 1978 and 2013

The house was constructed around 1780, and overlooked a stretch of the Newcastle to Derby turnpike road. It had been licensed as a public house by 1781, the first landlord being James Barlow. By 1912, the pub was advertising one of the best-frequented bowling greens in the Potteries, as well as the most superior billiard tables in the Stoke district. Frederick Latham kept the pub for eighteen years, until his death in 1951. Major renovation took place in 2000.

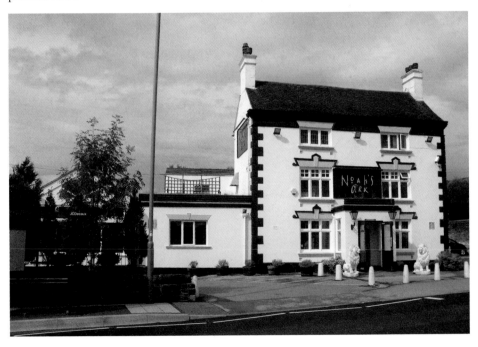

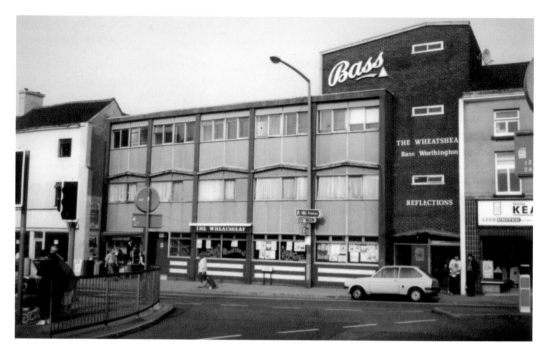

Wheatsheaf, 1991 and 2013

The Newcastle to Stoke Canal, authorised in 1795, formerly ran beneath the Wheatsheaf, re-emerging to public view in Campbell Place. In 1846, a policeman saw a hat floating on the canal near the Wheatsheaf. Upon reaching for the hat, he noticed a flailing arm, which he duly seized. He hauled the intoxicated Thomas Johnson to *terra firma*, and at the resultant court hearing, it was stated that Johnson would have drowned but for the intervention of the keen-eyed officer.

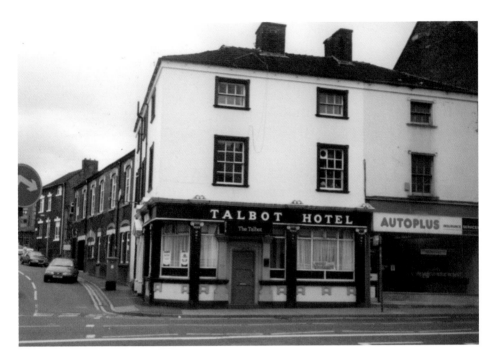

Talbot, 1993 and 2013
The historian John Ward wrote, around 1840, that 'there are in Penkhull with Boothen, 10 Inns or Public Houses (of which the Wheat-Sheaf and the Talbot, in Stoke, are of a superior class). Of Beer-Houses, there are about thirty.' Within living memory, the Talbot became a noted music venue, mainly due to the enterprise of Hazel Nicklin, who ran the pub from 1983 to 1993. Hazel died, on 31 March 2007, aged sixty-four.

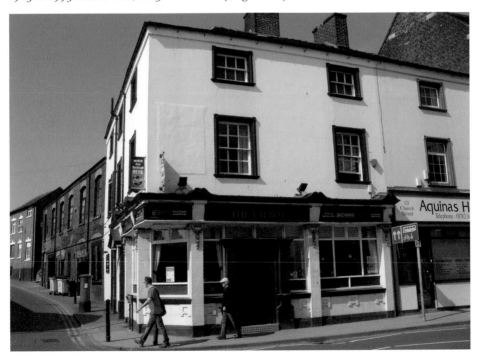

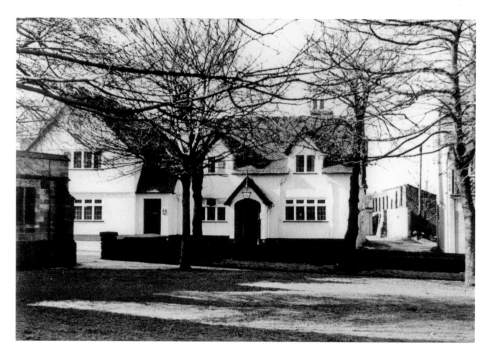

Greyhound, Penkhull, Date Unknown, and 2013

The historic Greyhound is photographed here from St Thomas's churchyard. Documents dated 1927 indicate that the pub's fixtures and fittings back then included cast-iron spittoons, cases of stuffed birds, a board for playing cards, oil paintings and eighteen old iron quoits. The property included a front smoke room, a back smoke room, a tap room and a bar. Outside, there was a large signboard, bearing the legend, 'Greyhound Inn – Parker's Fine Ales.'

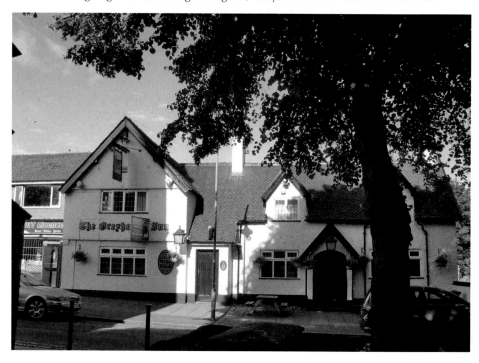

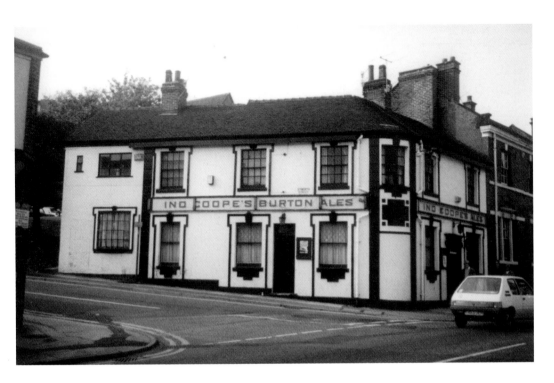

Former Sea Lion, 1991, and Gray's Corner, 2013
The Sea Lion underwent a name change to Ye Olde Bull and Bush in the mid-1980s, and was deliberately reinvented as a turn-of-the-century traditional pub, with real sawdust on a ceramic tiled floor. It was a novel idea that did not stand the test of time. Still standing to the right of the pub is a Georgian house with a robustly pedimented door frame.

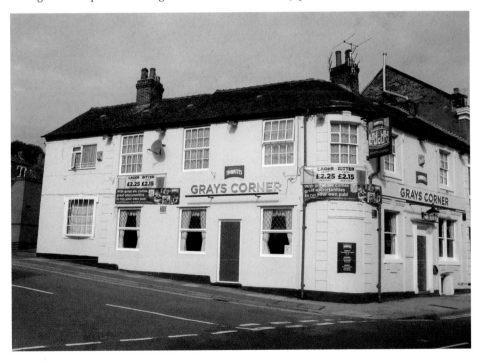

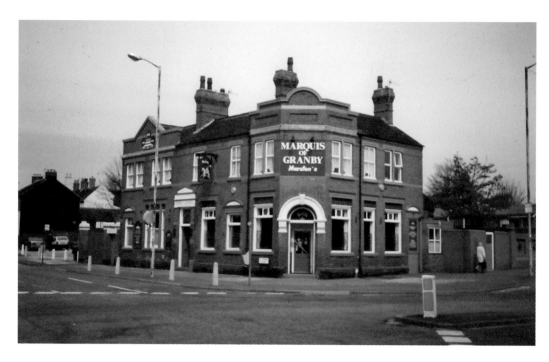

Marquis of Granby, Penkhull, 1994, and Licensee John Rowland, 2013

Among the societies who met at the Marquis in the nineteenth century were the North Staffordshire District of the Grand Union of Oddfellows (Marquis of Granby Lodge). Their tea party, held in November 1861, saw the lodge room decorated with festoons and garlands. Musical entertainments were provided and dancing was kept up until the early hours of the next morning. The pub is presently run by John and Carole Rowland.

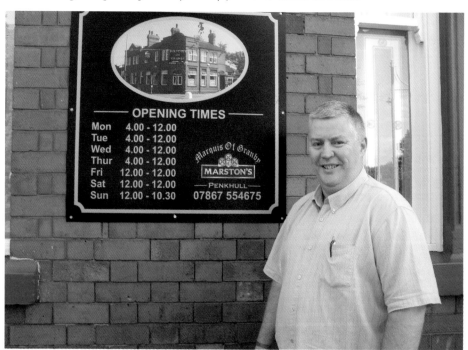

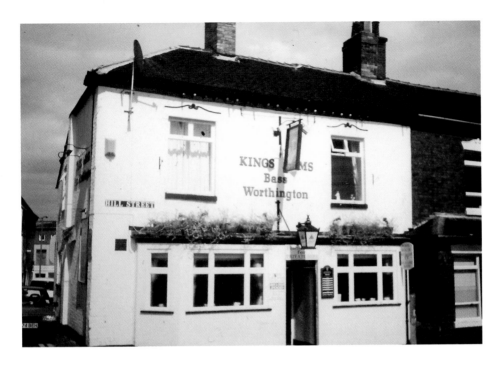

Kings Arms, 1994 and 2013

This Hill Street pub has an interesting claim to fame, according to a 2008 *Sentinel* interview with reader Barry Seckerson of Oakhill, near Stoke. He was in the Kings Arms 'in the latter part of 1959', when he witnessed five young men having a break from their live show at the Danilo just above. They were Cliff Richard and the original Shadows line-up. Barry managed to cadge tickets for the second half of Cliff's show.

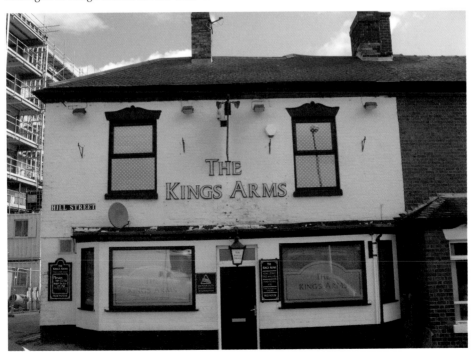

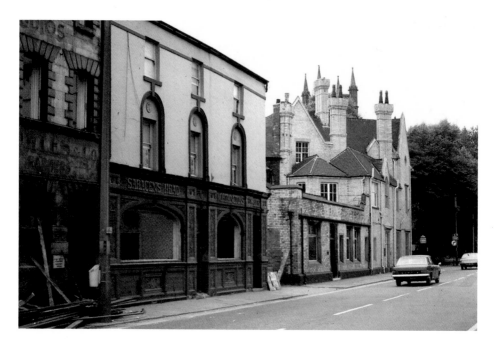

Site of Saracen's Head, Glebe Street, 1970s and 2013

The Saracen's Head stood virtually opposite the Glebe Hotel in Glebe Street. Elizabeth Greatbatch is listed as keeping a beerhouse in Glebe Street in 1851, but at the annual licensing meeting at Trentham in 1857, 'Mr Stevenson made application for a license to be granted to Mrs Elizabeth Greatbatch, of the Saracen's Head, opposite the Town Hall, Stoke, which was granted...' The above photograph shows the pub in the course of being demolished.

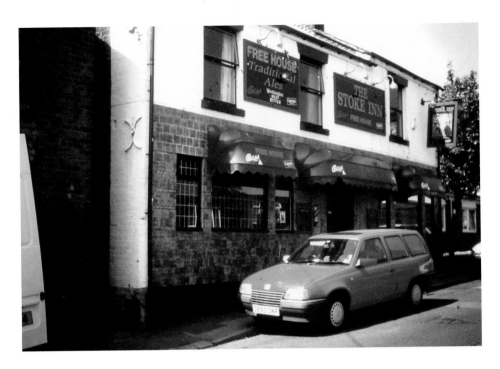

Stoke Inn, 1998, and Albert, 2013

The historic name of this pub was The Albert, but as the top photograph shows, it underwent a name change. The pub was refurbished and reopened as The Albert on 20 August 2007. The Albert – then a beerhouse – appeared in the police court reports in 1875. Samuel Turner, a Penkhull labourer, was charged with being drunk and disorderly after drinking two gallons of beer!

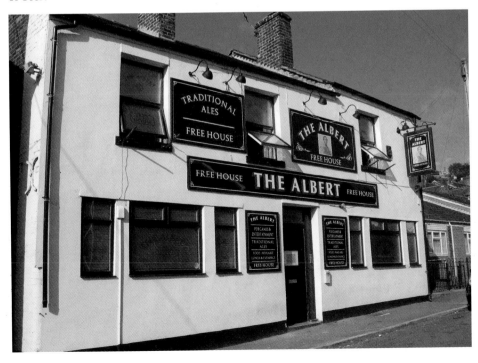

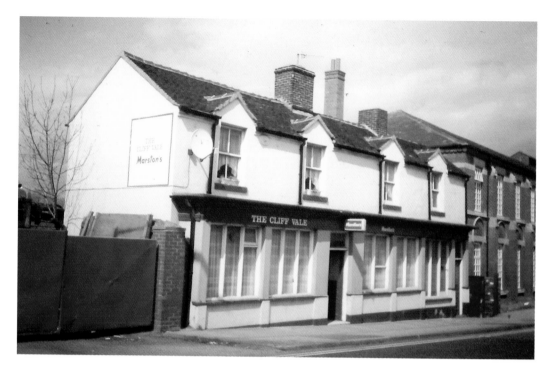

Cliff Vale, 1994 and 2013

Even when it was trading, the Cliff Vale in Shelton Old Road barely seemed inviting. It had shabby curtains and a time-battered frontage, and might even have passed for a chapel of rest. However, it was loved by many people for its idiosyncratic interior, embracing a bar on the left and a little-used lounge on the right. One of the last time-warp boozers in Stoke-on-Trent, it sold probably the best pint of Pedigree in the Potteries.

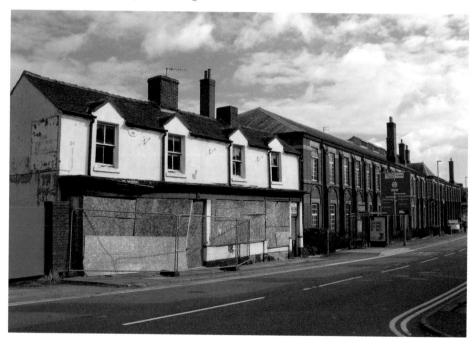

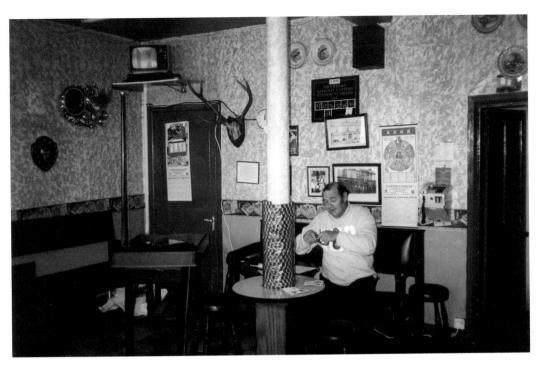

Cliff Vale Landlord, Joe Mayer, 1998, and Pub Exterior, 2013

Joe Mayer was the long-serving landlord of the Cliff Vale. Born in Sandyford in 1946, he later lived in Goldenhill, Chell Heath and Blurton. He boxed for the city as a schoolboy, but upon leaving school, he worked at Hem Heath Colliery. He served in the Army between 1964 and 1967 and boxed for his regiment, the 65th Lancers, quitting boxing in his early twenties. He also worked for Foden's in Sandbach before becoming involved in the licensed trade.

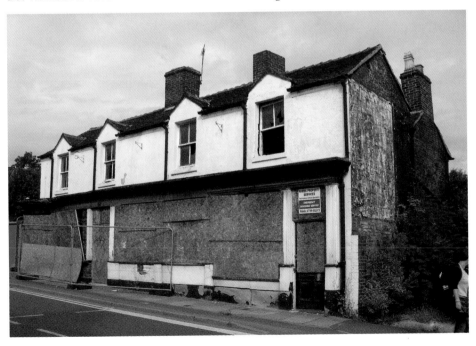

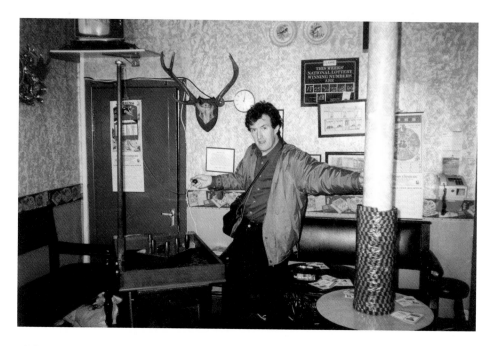

Cliff Vale and Mervyn Edwards, 1998, and Pub Exterior, 2013

This interior photograph shows a pair of deer's antlers, bought by Joe's sister for £20 at an auction. The pub was well-known for its Penny Pile – which contained about £500 when full – and its charity collections, such as those for Father Hudson's homes. The Fred Rigby bar was named after a character who lived in nearby North Street. Fred's photograph was pinned on the games chalkboard, with a caption suggesting a look-a-like for him: 'Dean Martin – alias Fred Rigby.'

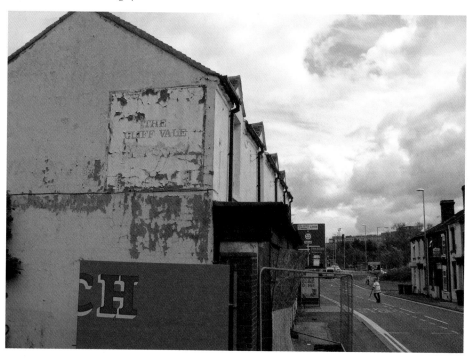

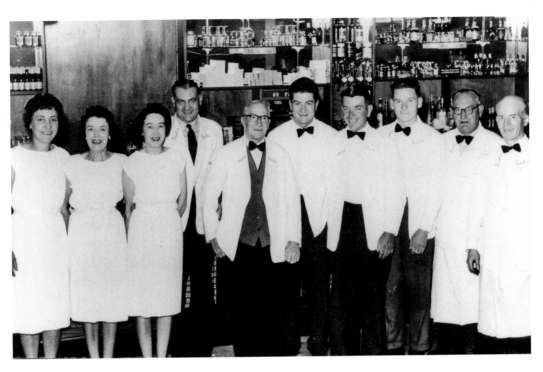

Staff at Jubilee WMC, Trent Vale, c. 1959, and the Club, 2013

The Jubilee Working Men's Club & Institute opened in 1935 in a large house that was bought by the club officials and partly reconstructed. Three upstairs rooms were made into one large billiard with concert room. The Jubilee was affiliated to the Club and Institute Union. Jean Ridgway, a correspondent of the author, reveals that the four people on the left of the top photograph are: Cathy Dulson and Elsie Bates (both barmaids), Flo Baddeley and Albert Baddeley.

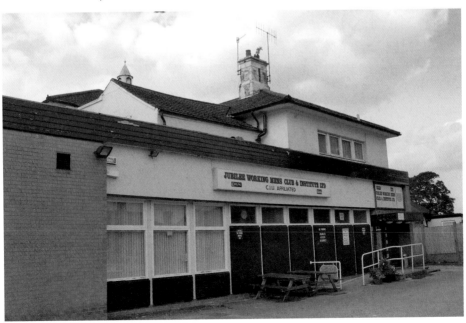

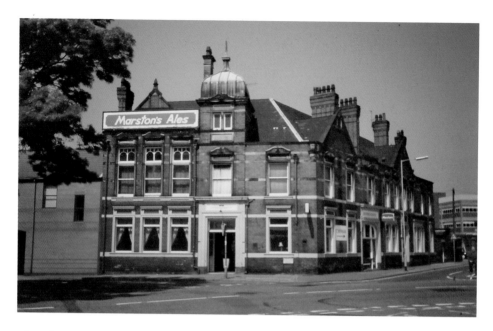

Victoria, 1998 and 2011

This huge, brick Fletcher Road pub was extremely convenient for football supporters when Stoke City played at the old Victoria Ground. It boasted of an impressive staircase leading from the bar to the first floor – 'reminiscent of the wild west', according to the CAMRA Potteries beer guide of 1984. On the author's last visit, in 1992, the high ceilings of the several rooms made voices echo. One room housed a brace of pool tables and some heavily vandalised seat upholstering.

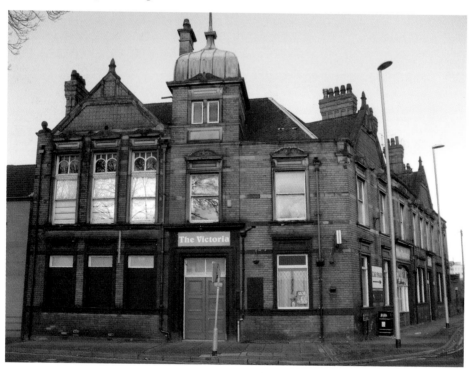

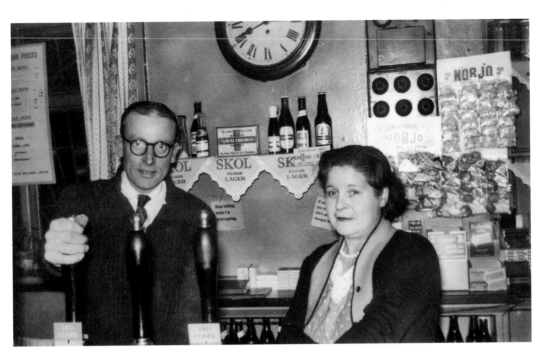

George Inn, Vale Street, c. 1960, and Vale Street, 2013
Vale Street connects Liverpool Road and Hartshill Bank. Landlord Tom Cadman and his wife Elsie pose behind their bar counter at this long-gone Stoke pub. A joke sign behind the staff states: 'Stop talking while I'm interrupting.' The 1900 Ordnance Survey map shows a very different Vale Street, with packed terrace housing on both sides.

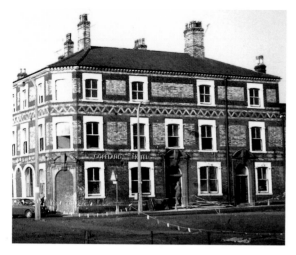

Copeland Hotel, 1970s
The *Directory of the Potteries and District* (1912) advertised the Copeland Arms Hotel as having been reconstructed and decorated. It offered commercial and coffee rooms, as well as a billiard room. The Copeland was popular with Town Hall staff and businessmen on account of its reputation for meals at a time when relatively few pubs sold food. However, in the 1970s, thirteen Stoke pubs were demolished to make way for the D Road. The Copeland Hotel was one of the casualties.

Acknowledgements

Bob Adams, Barewall Art Gallery, Eva Beech, Julie Cadman, Susan Coates, Crich Tramway Museum, Ken Cubley, Sylvia Davenport, Pauline Dawson, Ken Edwards, Marie Haywood, Harold Holdway, John Martin, Millar and Harris SW, Bob Newton, Laura Phillips, Cliff Proctor, Maureen and Norman Prophett, Jean Ridgway, Marc Robinson, the *Sentinel* newspaper, the Spode Museum Trust, Stoke Minster and Prebendary David Lingwood, Dr David Taylor, Gary Tudor, Keith Warburton and Alan White.

The Spode Museum Trust was established in 1987 to protect the archive and collection from the Spode and Copeland factory in perpetuity. The collection and archive includes around 40,000 ceramic items, 25,000 engraved copper plates, from which transfer prints were taken for printed ceramic wares, as well as factory tools, furniture, moulds, and 250,000 Spode and Copeland documents, including pattern books with detailed watercolour paintings of some 70,000 ceramic patterns.

Spode stayed on the same factory site from 1776 to 2008, and the factory owners threw very little away. Because of the timespan and it near completeness, the Spode Museum Trust's collection and archive offers a unique insight into the history of a world-famous factory, from the Industrial Revolution to the present day.

Following the closure of Spode's historic factory at Church Street, Stoke, in 2009, the collection was put into secure storage. With the support of a Heritage Lottery Fund grant and assistance from Stoke-on-Trent City Council and others, a two-year project, the Spode Works Visitor Centre, is open during 2013 and 2014 in one of the historic buildings on the Church Street site. The Trustees of the Spode Museum Trust are working to establish a permanent home for the collection. Website: www.spodemuseumtrust.org.

Every effort has been made to correctly identify copyright owners of the photographic material in this book. If, inadvertently, credits have not correctly been acknowledged, we apologise and promise to do so in the author's forthcoming title for Amberley Publishing. Much caption information was personally supplied by the above people. Readers are asked to allow for minor errors of memory.